IMAGES
of America

COAST GUARD
CUTTER *TANEY*

Bob Ketenheim

ARCADIA
PUBLISHING

Published by Arcadia Publishing
Charleston, South Carolina

Printed in the United States of America

Library of Congress Control Number: 2017943861

For all general information, please contact Arcadia Publishing:
Telephone 843-853-2070
Fax 843-853-0044
E-mail sales@arcadiapublishing.com
For customer service and orders:
Toll-Free 1-888-313-2665

Visit us on the Internet at www.arcadiapublishing.com

To the crew of Coast Guard cutter Taney.

CONTENTS

ACKNOWLEDGMENTS

I wish to thank the following *Taney* crewmen who donated photographs to the Historic Ships of Baltimore, some of which are used in this book: George Brungot, Garrett Conklin, Glenn Hangard, Edward C. Hartmann, Bill Morgan, Gordon Reddick, and Clint Reierson. I also thank Linda Palmer, daughter of Lee Owen Power, who donated photographs of her late father. I thank Brian J. Whetstine, whose book *The Roger B.* was very helpful in writing several of the captions. I thank CPO Tom Harroll, US Naval Reserve (retired), who helped me get this project off the ground. I thank F. Paul Galeone for allowing the use of his professional photograph. I thank the many members of the *Taney* museum staff who were always ready to answer questions and show me around the ship.

I owe a special thank-you to site manager Ryan Szimanski for sharing his *The Legend of Soogie: 1937–1948* with me.

A very special thank-you and "Bravo Zulu" (well done) go to curator Paul Cora. Paul spent many hours sharing photographs and stories that make up the bulk of this work. He was never too busy to help me. A person more knowledgeable about *Taney* cannot exist.

I thank Caitrin Cunningham and Sarah Ybarra of Arcadia Publishing for their assistance and their encouragement.

Unless otherwise noted, all images came from the files of Historic Ships of Baltimore aboard Coast Guard cutter *Taney*.

INTRODUCTION

US Coast Guard cutter *Taney* was one of seven Secretary-class cutters built during the Great Depression. They were built as part of Pres. Franklin D. Roosevelt's Works Progress Administration to help keep the country's shipyards operating. *Taney* and three of her sister ships were built at the Philadelphia Navy Yard. *Taney* was named for Roger Brooke Taney, a Maryland native who served a brief period as acting secretary of the treasury for Pres. Andrew Jackson.

Soon after commissioning, the cutter *Taney* was ordered to Hawaii. The ship operated out of her home port of Honolulu. She patrolled the equatorial Line Islands, patrolled the area around the Hawaiian Islands against narcotics smuggling, and participated in the search for the lost aviator Amelia Earhart and her navigator, Fred Noonan.

In 1937, *Taney*'s longest-serving crew member reported aboard. She was a rat terrier named Soogie, who stayed aboard the ship until 1948.

In 1940, the ship's name was shortened to just *Taney*. Sensing war in the Pacific was near, all seven Secretary-class cutters were transferred from the Coast Guard to the US Navy. The white-hulled *Taney* was painted gray and re-designated USS *Taney* (CG). On December 7, 1941, she was moored at Pier 6 in Honolulu near the Honolulu electric power plant. Once the Japanese attack on Pearl Harbor began, *Taney* immediately went into action. She engaged several groups of attacking planes with antiaircraft fire and is credited with saving the city's power plant.

After the attack, *Taney* patrolled the waters around Oahu as part of Destroyer Division 80. In April and May 1942, she was reconfigured in the Pearl Harbor Navy Yard for convoy escort duty. In June, she was dispatched to Midway Island to resupply the island and search for survivors of the recent battle there. For the remainder of 1942 until late 1943, *Taney* patrolled the waters around Hawaii and made occasional trips to the Line Islands.

In July 1943, she was ordered to transport a survey team to Baker Island for the purpose of building an airfield. After tangling with a Japanese long range patrol plane, she departed Baker Island but returned with naval air cover to finish the job.

In late 1943, *Taney* went into the Mare Island Navy Yard for a refit and was armed with four dual-purpose 5-inch/.38-caliber enclosed gun mounts. She was also fitted with numerous 20mm Oerlikon antiaircraft guns and antisubmarine weapons. She then shifted to the East Coast for convoy flagship duty. She arrived in the Boston Navy Yard in March 1943 to have a combat information center installed.

As a convoy flagship, *Taney* escorted convoys from April 1944 until September 1944. The convoys she escorted were in support of the Italian campaign. Convoy USG-38 was attacked by German torpedo bombers on the night of April 20, 1944, in the Mediterranean Sea. Two merchant ships in the convoy were sunk, one US destroyer was sunk, and two more merchant ships were damaged.

After convoy duty, *Taney* reported to the Boston Navy Yard in October 1944 for an extensive conversion to an amphibious group command ship. The enclosed gun mounts were removed

and replaced by two open mount guns. Three twin 40mm mounts were added for antiaircraft protection. After the conversion was completed in January 1945, she shifted back to the Pacific campaign, where she became the flagship for Navy Rear Admiral Calvin H. Cobb.

The Okinawa invasion began on April 1, 1945, as the final step in preparation for the invasion of Japan. *Taney* arrived there on April 11, and was in the thick of battle during the days of the heaviest kamikaze attacks on the US fleet. *Taney* shot down five Japanese planes in defense of herself and surrounding ships.

After the war abruptly came to an end, *Taney* remained in Japanese waters until October 14, 1945, to assist with the evacuation of allied prisoners of war. She then departed and headed for San Francisco, where she arrived on October 29. She docked at Government Island at Alameda, California. Her stay there was short as she was ordered to the Charleston Navy Yard in South Carolina. There, she underwent a reconversion back to a peacetime ship. All the deck houses and decks added to her for the war were removed. By the end of 1946, she was painted white and looked more like her original 1930s design.

During World War II, although manned by a Coast Guard crew, she operated under the control of the Navy. Back under Coast Guard control by 1946, *Taney* began a 30-year tour of duty as an ocean weather station patrol ship. Before the days of weather satellites, ships took up station in the Atlantic and Pacific to gather weather information and report it back to the US mainland. The Coast Guard ships on ocean station also provided a safety net for aircraft and commercial ships transiting the open ocean. Always alert for distress calls, *Taney* had to leave her assigned station on numerous occasions to come to the aid of ships or aircraft in distress.

Taney took a break from ocean weather station duty in 1969 for a tour of duty in South Vietnam. She provided naval gunfire support for allied troops ashore and patrolled the South Vietnam coast as part of Operation Market Time to interdict the movement of enemy troops and supplies by small boats.

She returned to the United States in March 1970 and resumed ocean station duties. In 1971, *Taney* was again transferred to the East Coast. She underwent an extensive rehabilitation and modernization overhaul at the US Coast Guard yard in Curtis Bay, Maryland. Once refurbished, she resumed weather station duty on Ocean Weather Station Hotel, 200 miles off the New Jersey coast. When weather stations were discontinued on September 30, 1977, *Taney* earned the distinction of being the last Coast Guard ship to serve on an ocean weather station.

Operating out of Portsmouth, Virginia, *Taney* spent the remaining years of her 50-year career on North Atlantic fisheries patrols and patrolling the US East Coast and the Caribbean Islands. A large part of her duties was the search for drug smugglers. In 1985, she made the largest drug bust in US history at that time. *Taney* stopped and searched a vessel that was towing a barge and discovered it held approximately 160 tons of marijuana wrapped in 4,176 bales. The estimated street value was $132 million in 1985.

With more modern and faster Coast Guard cutters now in service, *Taney* was decommissioned in Baltimore, Maryland, on December 7, 1986. Her last commanding officer was Comdr. Winston G. Churchill. She had been in continuous service to the United States for 50 years, one month, and 13 days.

Today, *Taney* rests in Baltimore's Inner Harbor as part of the Historic Ships of Baltimore. She is a museum ship open for public touring, and about 110,000 people walk her decks every year.

On December 7 each year, a Pearl Harbor remembrance ceremony is held on her main deck. She is the last US ship afloat that was present when the Japanese attacked Pearl Harbor.

One

THE 1930s

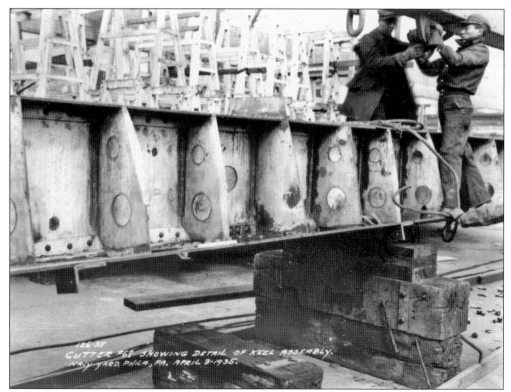

Coast Guard cutter *Taney* was known as cutter No. 68 when her keel was laid on May 1, 1935. She was one of four Secretary-class cutters built at the Philadelphia Navy Yard during the Depression. Her namesake was the 12th US secretary of the treasury. Two shipyard workers are seen here placing a section of the ship's keel on wooden blocks in preparation for joining the section into a solid unit.

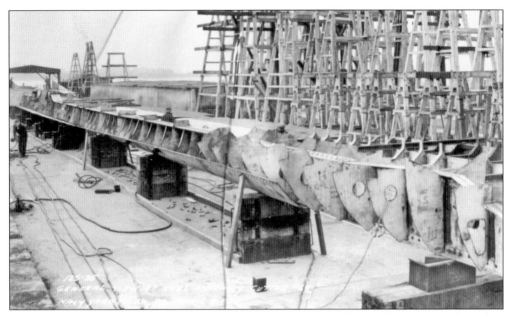

Construction continues on *Taney's* keel, with frames welded to the keel's sides. Bottom plating has been started and is held in place with wooden supports prior to riveting. The ship was built in a dry dock with three of her sister ships. The wooden blocks on which the keel rests were precisely measured to ensure that the keel was perfectly straight. The ship would remain on the wooden keel blocks until she was launched on June 3, 1936.

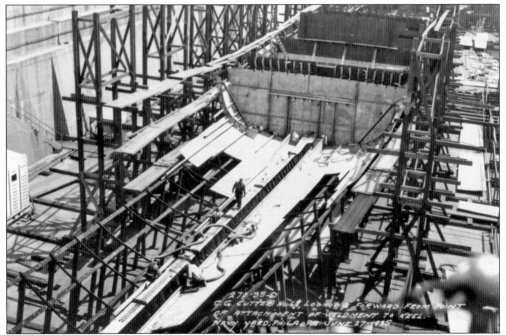

More of the bottom plates have been riveted to the keel, and the first watertight bulkhead has been installed. Note the lattice framework on both sides of the keel that aids the shipyard workers in forming the hull. The scaffolding on the sides of the ship provide the workers with access to the vertical structure. This view from late June 1935 is from the rear of the ship looking forward.

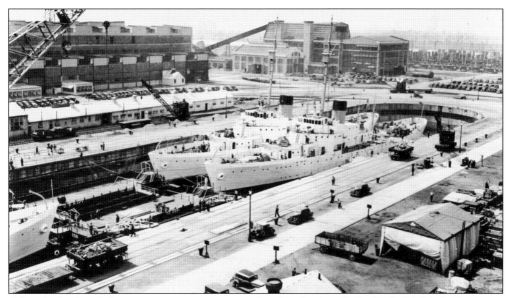

After the hull and the superstructure were completed and painted, the Philadelphia-built cutters remained in dry dock for several months while their interiors were completed. The guns and many of the deck fittings were also installed during that period. The christening platforms have been installed at the bow of each ship, indicating that this photograph was taken just before the ships were launched on June 3, 1936.

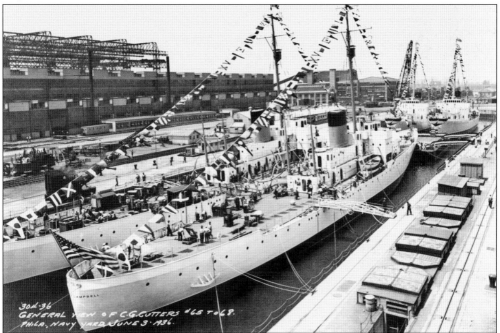

It is launching day for the three Philadelphia-built Secretary-class cutters. The dry dock has been flooded, and each cutter is dressed out with flags and bunting for the occasion. Because the cutters were all built at the same time, they were christened and launched on the same day, June 3, 1936. From left to right are (foreground) *William J. Duane* and *George W. Campbell*; (background) *Samuel D. Ingham* and *Taney*.

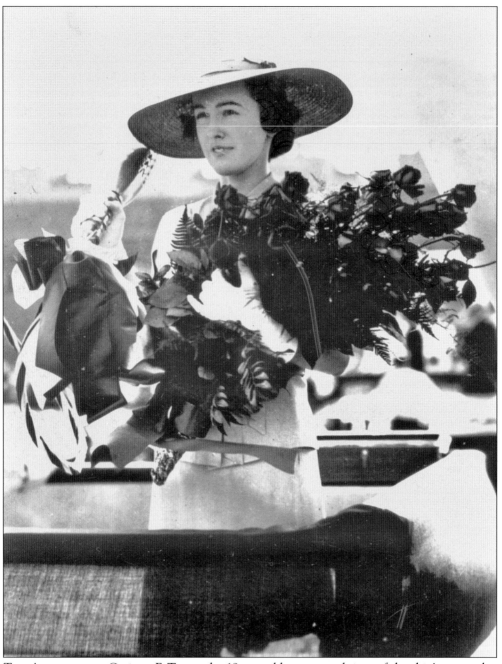

Taney's sponsor was Corinne F. Taney, the 19-year-old great-grandniece of the ship's namesake. She is pictured here standing on the platform at the ship's bow holding a bouquet of roses and a bottle of champagne.

Corinne Taney, standing on the wooden platform in front of *Taney*, along with the crowd in front of her, wait for the *George B. Campbell* to be christened. About 300 people, military and civilian, attended the christening of the four ships at the Philadelphia Navy Yard on June 3, 1936.

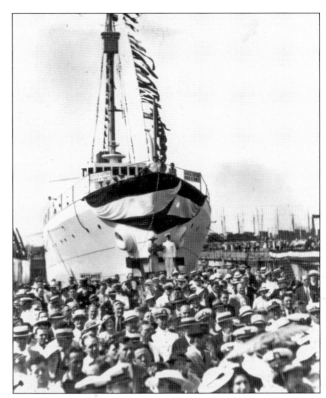

Corinne Taney breaks the traditional bottle across *Taney's* bow. Usually at such an event, once the bottle is broken on the bow and the sponsor wishes the ship and its crew well, the ship slides down the shipway into the water. However, because the cutters were constructed in a dry dock, the launching was accomplished by flooding the dry dock.

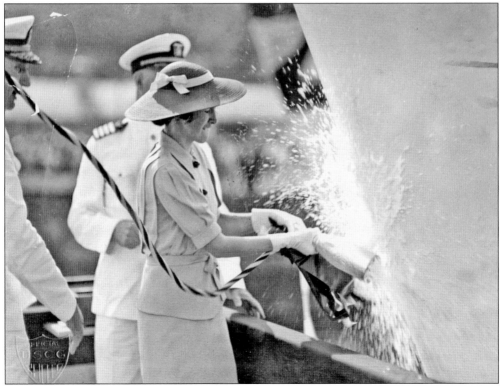

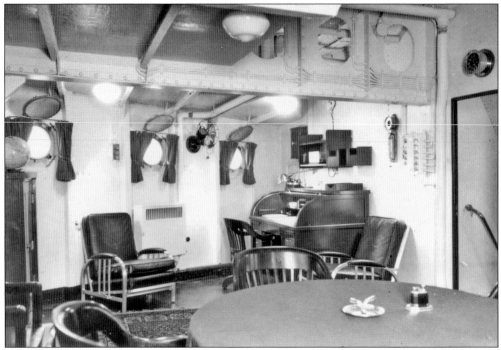

These two views show the captain's cabin. This is the most posh and spacious living compartment on the ship. Above is looking to starboard. Note the curtains on the portholes, the rug on the deck, and the large desk. Below is looking to port. The captain has a couch, a dining table, and a silver service set on the countertop. The "passing window" to the right of the silver service (below) communicates with the captain's pantry, where his meals are prepared. The captain uses this space to meet with his officers and to entertain VIPs and dignitaries who visit the ship. The captain's sleeping quarters are detached from his cabin.

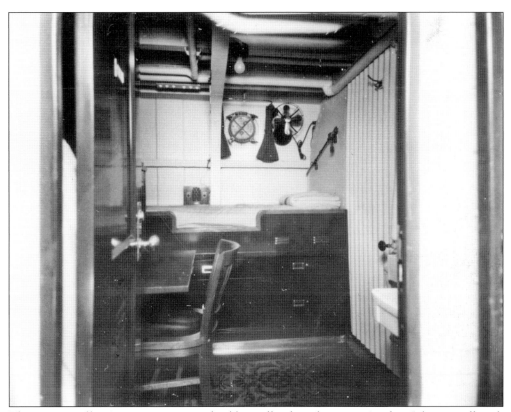

This warrant officer's stateroom is considerably smaller than the captain's cabin. It has a small work desk, a bunk, and a sink. The drawers below the bunk are for uniforms and personal belongings. Although it is small and cramped, even for one person, the stateroom is much more comfortable than the berthing area for enlisted men. Note the sword hanging on the bulkhead on the right. A sword is worn only with full dress uniform on special occasions.

Ship's crew sleeping quarters, also known as berthing compartments, are small and crowded. The bunks are canvas secured to aluminum tubing by rope. The firmness of the bunk can be adjusted by tightening or loosening the rope. Each crewman has a mattress, a pillow, a sheet, and a wool blanket. When not in use, the bunks are stowed, or "triced up," to facilitate easier cleaning of the deck. Uniforms and personal belongings are kept in metal lockers.

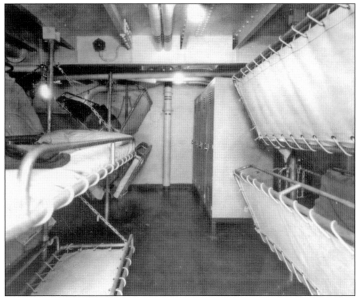

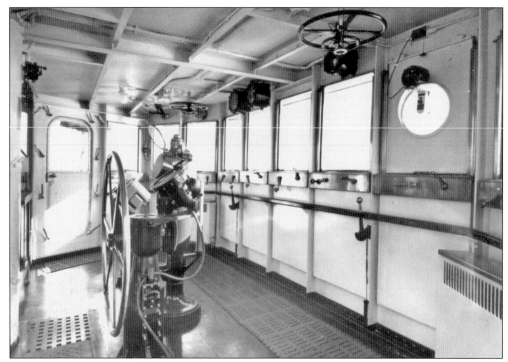

The pilothouse, also known as the bridge, is where the officer of the deck directs the motion of the ship while at sea. The helmsman steers the ship by the large wheel, and the lee helmsman notifies the engine room of speed changes by way of the engine order telegraph to the left of the wheel. The photograph above was taken looking from starboard to port. The wheels overhead are for adjusting the searchlights on the deck above. Looking aft in the pilothouse below, the handsets hanging on the stanchion are sound-powered phones to communicate with different parts of the ship. As built, the pilothouse was quite spacious.

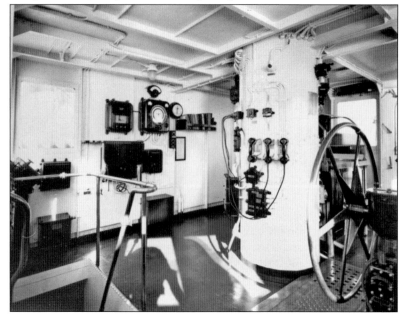

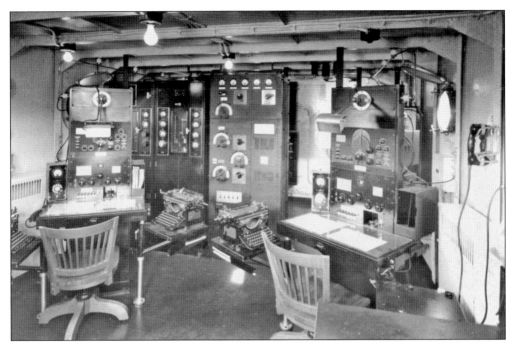

This antiquated radio room was the latest technology when *Taney* was commissioned in 1936. Radio equipment was much larger then because of heavy, all-metal construction and the use of vacuum tubes. Years later, transistors and circuit boards helped make radio equipment much smaller. The radio room was an important place on the ship. It was the center of communications with shore stations and other ships at sea. The radioman on watch would monitor several frequencies, including the emergency frequencies, for distress calls from ships and aircraft.

This is the ship's hospital, or sick bay, as it is known in the Coast Guard and Navy. Life aboard a ship is often dangerous, and injuries are to be expected. *Taney* was well equipped to handle such emergencies. The ship's sick bay included an operating table, a steam powered autoclave instrument sterilizer, and an isolation ward. The hospital corpsmen who manned the facility would treat minor illnesses and injuries and administer inoculations. When *Taney* was on extended patrols, she carried a doctor from the US Public Health Service.

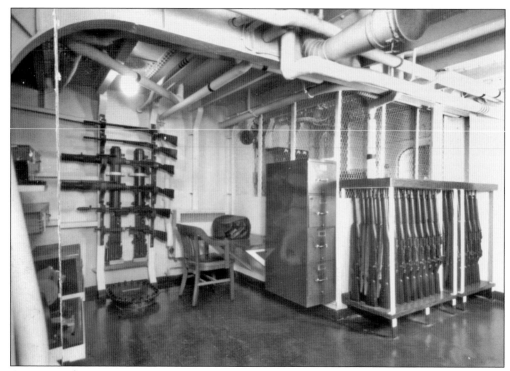

Coast Guard cutters perform a variety of tasks. Some involve law enforcement, such as stopping drug trafficking, gunrunning, smuggling, and illegal fishing. Such duties may involve boarding suspect vessels at sea; therefore, a variety of small arms are carried aboard the cutters. This is *Taney's* armory shortly after she was commissioned. Rifles, shotguns, and light and heavy machine guns are securely stowed in their racks. The ship's gunner's mates were responsible for cleaning and maintaining the weapons and ammunition.

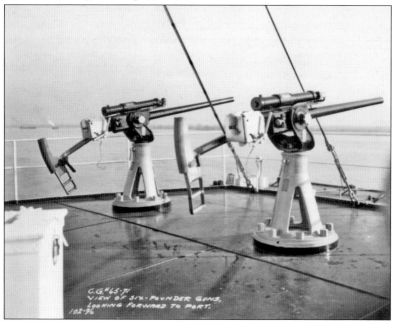

Two six-pounder naval guns were installed on *Taney*. The term "six-pounder" referred to the weight of the projectile the gun fired. Aboard *Taney*, these guns were "saluting guns" used to render honors.

Taney carried two .50-caliber machine guns. This short-range weapon would be replaced by the longer-range 20-millimeter Oerlikon gun and the 40-millimeter Bofors antiaircraft gun during World War II. The metal railing surrounding the gun and the metal tubing under the gun's barrel prevent the gun from being pointed at the ship's superstructure.

One responsibility of the US Coast Guard is responding to ships in distress. This may involve towing a disabled ship to safety or freeing a ship that has run aground. Therefore, Secretary-class cutters were equipped with a heavy-duty towing capstan and towing bitt on the stern of the ship. Because of the tremendous force involved in such an operation, the towing bitt was riveted to the steel structure of the ship and not to the wooden deck. These capstans were built specifically for the Coast Guard by the Silent Hoist & Crane Company of Brooklyn, New York.

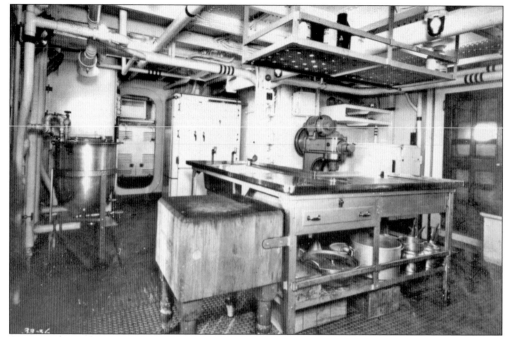

The ship's galley is where meals are prepared for the crew. These two views show *Taney's* galley. Shipboard galleys contain everything that a kitchen at home contains, but on a much larger scale. Notice the large, permanently mounted kettles for cooking vegetables and soups. Also visible are a mixer and a chopping block. The ovens and refrigerators are much wider, deeper, and taller than those found at home. There are several sinks for food preparation. The heat in the galley can get close to the heat in the ship's engine room, so fans and ventilation ducts are very important. Note the wooden screen doors set inside the watertight doors on both sides, for ventilation. This galley was expected to prepare meals for over 100 crewmen three times a day.

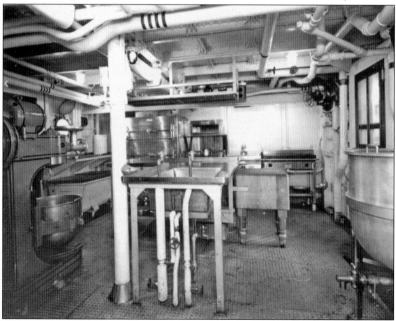

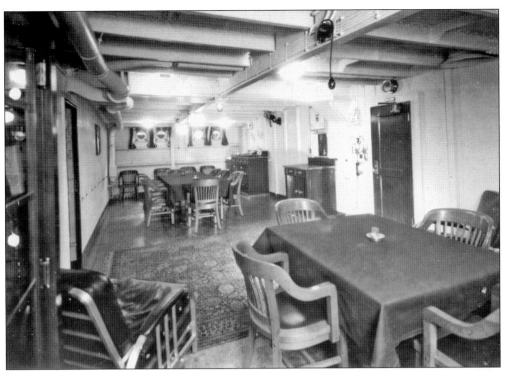

Taney's wardroom is the dining facility for the ship's commissioned officers. Between meals, it served as a place for the executive officer to meet with the ship's department heads. The executive officer, or second in command, was in charge of the wardroom. The ship's captain did not eat in the wardroom; he ate his meals in his cabin. The captain only ate in the wardroom when invited by the executive officer.

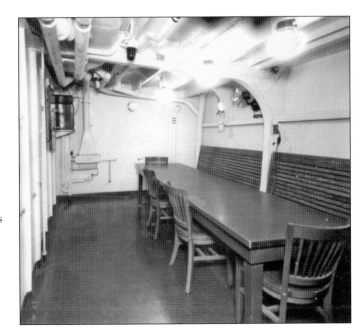

Chief petty officers (CPO) are the senior enlisted personnel in the Coast Guard and Navy. They eat in their own dining facility aboard ship, called the CPO mess, separate from the officers and the other enlisted personnel. The CPO mess is also a place where the chiefs would gather during off-duty hours to socialize and watch movies. The CPO mess is off-limits to anyone who is not a chief unless they are invited. This was *Taney's* CPO mess when she was built; it was later moved.

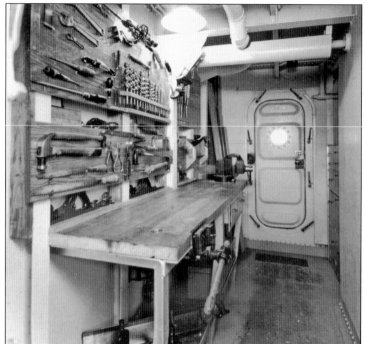

One might not think a steel ship would have a need for a carpenter's shop, but she does. A major concern for the ship's carpenter is maintenance of the wood on the ship's main deck. There are also repairs to the ship's wooden boats and wooden furniture such as office chairs, tables, and officers' stateroom bunks. Another important use of wood aboard a steel ship is to make shoring timbers to temporarily patch damage to the hull in case it is breeched as a result of battle damage or a collision.

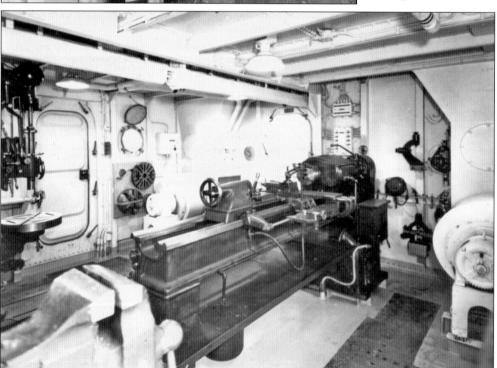

The ship's machine shop is fully equipped to handle almost any mechanical need. The machinist's mates who work here are responsible for repairing the ship's metal fittings, the ship's engines, and the ship's small boat engines. The shop is equipped with saws, drill presses, grinders, vises, a 14-inch metalworking lathe, and welding equipment.

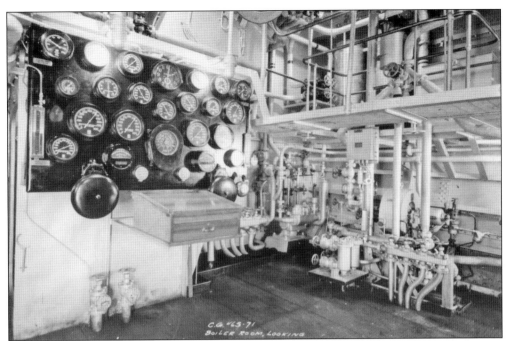

In the boiler room, water is brought to a boil to provide 417° F superheated steam for the ship's propulsion turbines. The boiler room is also known as the fire room. In the days of coal-burning ships, the water was brought to a boil using a coal fire, and the term "fire room" has hung on. Modern ships burn fuel oil to heat the water. Boiler room temperatures are usually over 100 degrees, which makes the working conditions demanding.

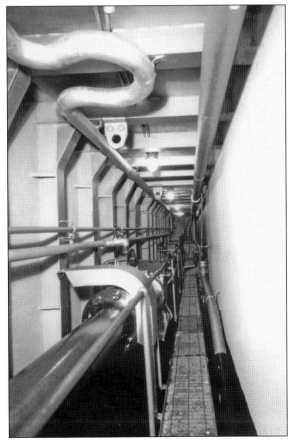

This is *Taney's* port shaft alley. The shaft alley is a long, narrow compartment in the bottom of the ship where the propeller shaft passes between the reduction gear and where the shaft exits the hull to connect to the propeller. The narrow walkway to the right gives a crewman access to the length of the shaft so he can check for proper lubrication and overheating.

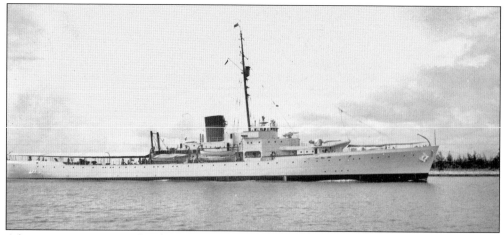

After commissioning on October 24, 1936, and before she was declared fully operational, *Taney* had to undergo a shakedown cruise and sea trials. The purpose of the shakedown is to ensure that the ship's crew and all the ship's new equipment are operating properly. Deficiencies in the crew would identify areas for more training. Deficiencies in the ship might require a return to the shipyard for repair or replacement of the problem equipment.

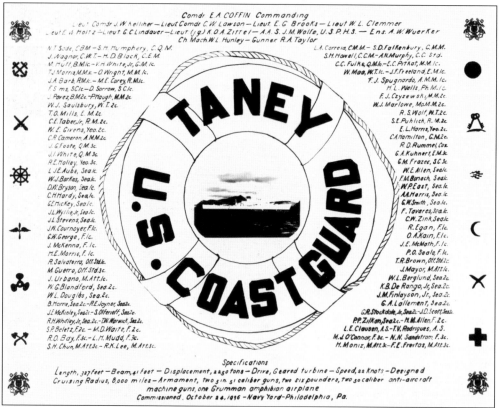

The names listed here are the ship's commissioning crew. Members of a commissioning crew in the Coast Guard and Navy are also known as the ship's "plank owners." Although the term is not an official designation in either the Coast Guard or Navy, it does bestow bragging rights on the crewmen, who could claim ownership of one of the planks on the ship's main deck.

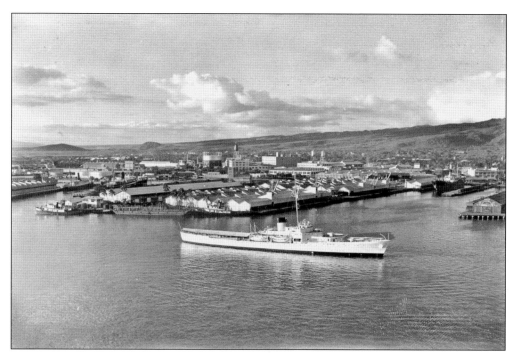

Taney's first duty station was Honolulu, Hawaii, where she reported on January 18, 1937. She patrolled the waters around the Hawaiian Islands to enforce US fishing regulations and to interdict drug smuggling. Duty in Hawaii had its pros and cons. It was a glamorous place where the weather was nearly perfect most of the year, and the outdoor activities were limitless. On the other hand, Hawaii is far from the US mainland, making going home on leave difficult if not impossible.

Part of *Taney's* duties was patrolling for drug smugglers. Here she follows a commercial ship headed for Honolulu. *Taney's* crewmen closely watched for illegal activity. One trick used by smugglers was to drop weighted packages of contraband overboard in shallow water close to shore. Later, swimmers in small boats would retrieve the packages and bring them ashore.

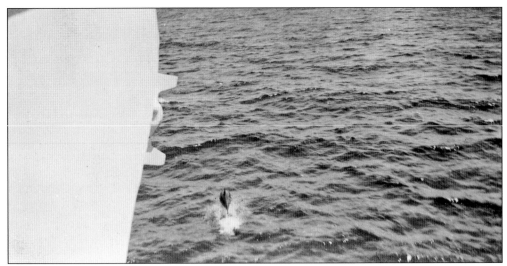

Dolphins racing in front or alongside a ship's bow have fascinated people for centuries. One explanation is that the water pushed ahead of the ship helps a dolphin swim faster and with less energy. Another explanation is that other fish gather around a moving ship, and it provides an easy food source for dolphins. A third theory is that dolphins are playful mammals, and they swim and leap in front of ships just to have fun.

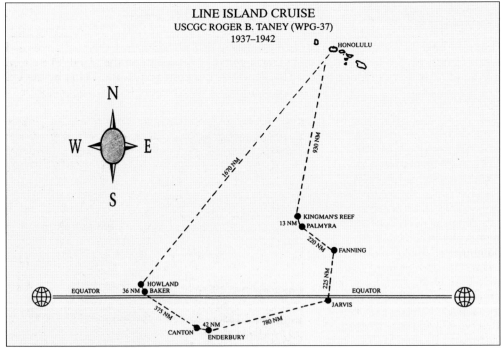

Line Islands patrol was another duty that kept *Taney* busy for several years after reporting to Honolulu. The Line Islands were US possessions along the equator 1,500 miles south of Hawaii. The US Department of Interior placed personnel on the islands so they could be claimed as American territories. *Taney* visited the islands monthly to transport and resupply the American colonists who lived there. The colonists were paid $90 a month for a three- to six-month tour. One of their duties was to make weather reports from the islands by radio to Hawaii. (Brian J. Whetstine.)

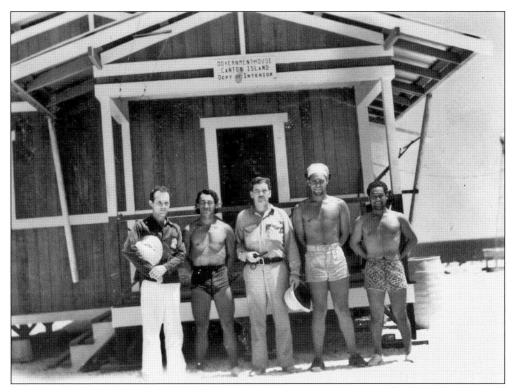

Canton Island was long the subject of an ownership dispute between the United States and Great Britain. Both countries maintained small groups of occupants on the island. These men are standing in front of Government House, which was built on Canton Island by the US Department of Interior. Richard Blackburn Black, US Department of Interior representative in Hawaii, is at center.

US Army Captain Newman (right) and Richard B. Black are pictured on the quarterdeck in late 1938. Black was the US Department of Interior representative in Hawaii who administered the US territorial islands. He accompanied *Taney* on several of the ship's Line Island cruises to make official island visits. Black was also a US Naval Reserve officer who accompanied Rear Adm. Richard E. Byrd during his Antarctic exploration in the early 1930s. Black would return to the islands aboard *Taney* during World War II. He retired from the Navy as a rear admiral, and passed away in 1992 at the age of 90.

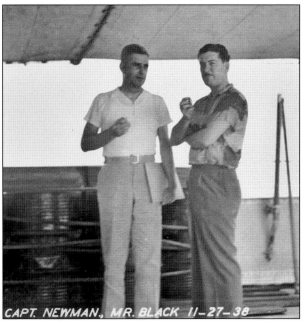

CAPT. NEWMAN, MR. BLACK 11-27-38

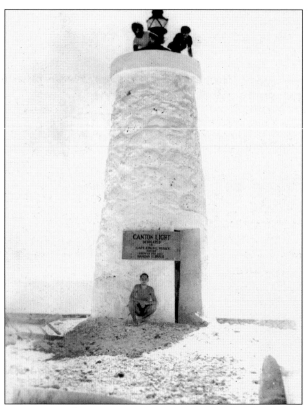

A small lighthouse was built on Canton Island as an aid to navigation. Because of the island's low profile, it was a hazard to ships steaming in its vicinity, especially at night. *Taney* crewmen would service the light during their routine visits to the island. Below, a group of men, including Richard B. Black, pose in front of the light under a plaque dedicating it to the crew of the *Samoan Clipper*. *Samoan Clipper* was a Pan American S-42 flying boat that exploded in midair on January 11, 1938, near Pago Pago, American Samoa. The pilot, Ed Musick, and the crew of six were killed. There were no passengers aboard. The plane was transporting mail and cargo. Pan Am Clipper flights used the Line Islands as navigation points on their trips across the Pacific.

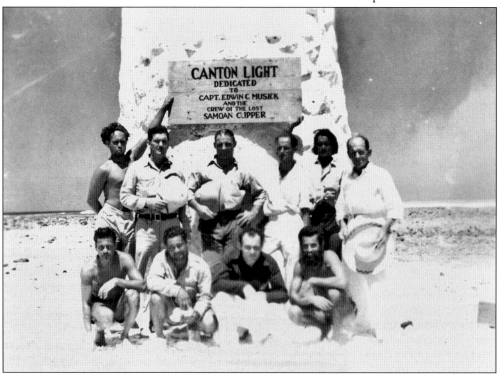

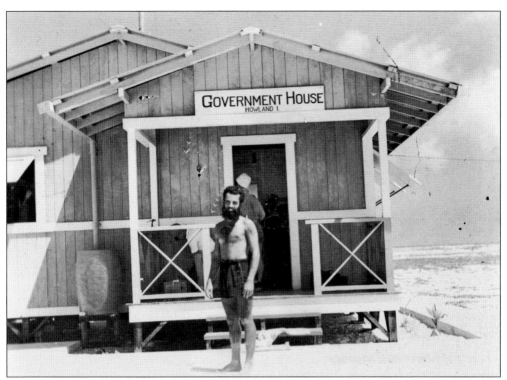

Howland Island was another of the Line Islands visited by *Taney*. Amelia Earhart and navigator Fred Noonan were trying to find the island when they were lost in 1937. This building was one of the structures erected by the US Department of Interior. The Japanese attacked the island on December 8, 1941, with 14 twin-engine bombers. Two of the four colonists placed there by the US Department of Interior were killed. The island was occupied by US Marines from September 1943 until May 1944.

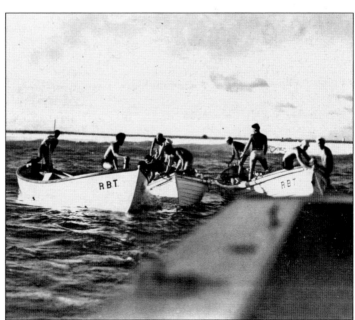

Several of the Line Islands did not have protected lagoons or anchorages, so when *Taney* visited, she needed to remain offshore. Personnel and supplies had to be transported from the ship to the beach in the ship's small surf boats. These boats were not motorized and had to be rowed by crewmen, which could be challenging in rough seas. The "R.B.T." on the boats identifies them as coming from *Taney*.

Civilians of the US Department of Interior lounge under the canopy stretched over *Taney's* quarterdeck. The quarterdeck was a popular gathering place both at sea and in port. The ship was not air-conditioned, which caused her interior spaces to become sweltering in the tropics. The canopy created a shelter from the sun, and the motion of the ship caused a cooling breeze to blow across the quarterdeck.

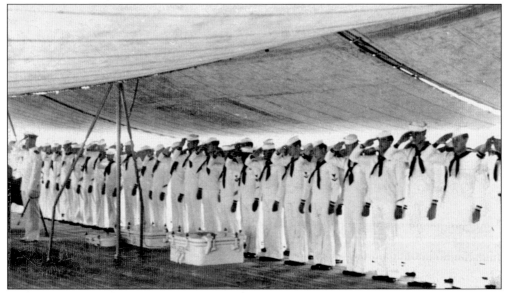

The crew stands at quarters saluting under the canopy stretched over the quarterdeck. The occasion is unknown, but it must have been special. The crew is in dress white uniforms, and the officer to the left is wearing white gloves and a ceremonial sword. Such dress is usually reserved for a special event such as visitation by a dignitary. Note that the enlisted crewmen wear the pre-war jumpers with dark blue cuffs with piping.

In the days before radar, *Taney* carried a Curtis SOC floatplane. The plane was lifted from its cradle on deck, swung over the edge of the ship, and lowered to the water, where it would take off. Once airborne, the pilot could see much farther than the ship's lookouts. When the scouting mission was complete, the plane would land near the ship, taxi close to the side, and be hoisted back on deck by the aircraft crane.

The aircraft crane was also used to lower small boats to the water or raise them to the deck. The boat being hoisted at the Philadelphia Navy Yard is a motorized surf boat from the US Coast Guard rescue station at Point Arguello, California. The wheeled device holding the drums in the foreground is the cradle for the ship's floatplane. The cradle is secured to the deck to keep it from rolling from the motion of the ship.

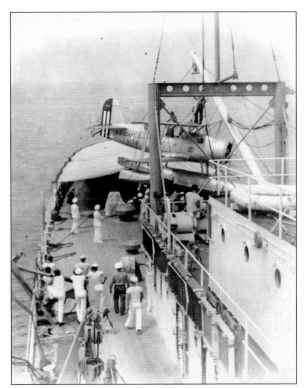

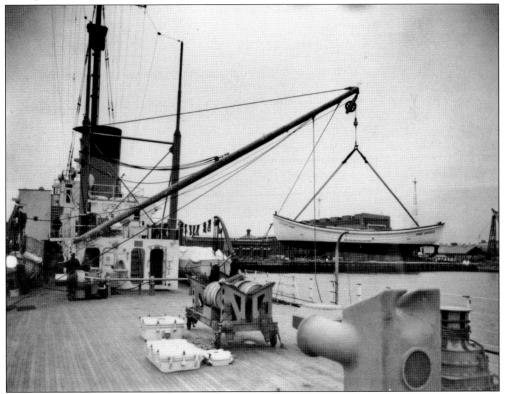

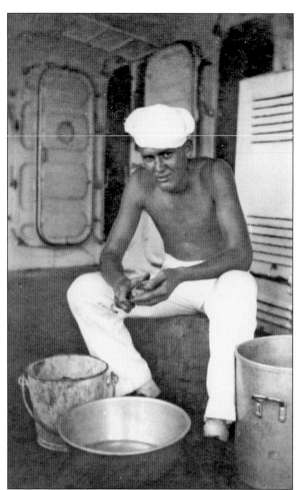

Seaman Second Class Douglas Carlson sits and peels potatoes on the port side of *Taney's* main deck. Potato peeling is not the most sought-after job in the military. In the days before automatic peelers, it had to be done by hand. Usually this was a daily task for the mess cooks, but on occasion, it was used as punishment for a minor infraction.

Radioman First Class Bill Atherton sits at a drawing table and sketches a cartoon during *Taney's* 1938 Line Island cruise. Atherton was a talented artist who entertained the crew with many sketches of life aboard ship, and was a regular contributor to the ship's newspaper. In 1939, Atherton was among the Coast Guard radiomen required to learn Japanese radio code because the Coast Guard district communications officer thought it might come in handy one day. Atherton retired from the Coast Guard as a chief radioman.

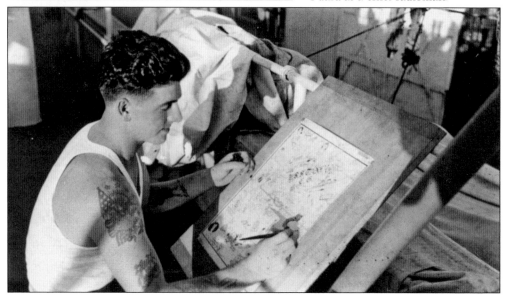

Two

SOOGIE'S STORY

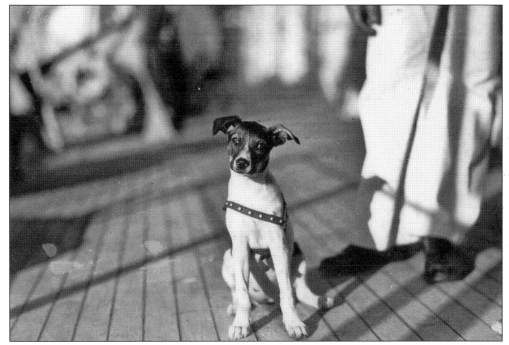

It was rare, but not unheard of, for a US warship to have a pet aboard as a mascot, particularly during World War II. If she did, it was usually for a short period. During World War II, at least one Navy attack cargo ship had a dog, three cats, and a monkey on board at the same time. In *Taney's* case, a dog came aboard in 1937 and stayed for 11 years, departing in 1948. The crew named the female part–rat terrier Soogie, which was Coast Guard slang for the unbranded scouring powder used for cleaning the ship.

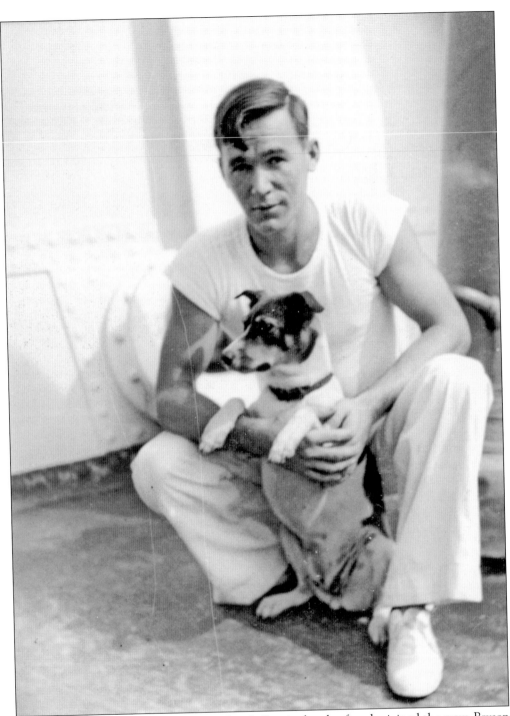

Seaman First Class Joe Bryson is pictured with Soogie shortly after she joined the crew. Bryson found the young puppy in a Honolulu bar being fed alcohol by several Australian seamen. Disgusted by this, Bryson grabbed the dog and left the bar. Under the influence of the alcohol, Soogie fell asleep, and Bryson was able to sneak her aboard ship undetected. *Taney* was at sea by the time Soogie was discovered by the ship's officers.

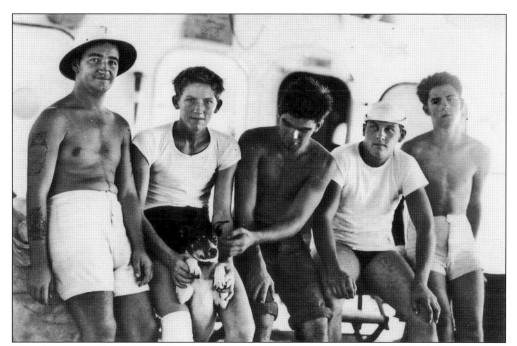

Taney's commanding officer, Comdr. Eugene A. Coffin, was not pleased, but he allowed Soogie to remain on board until the ship returned to Honolulu. It is not known what occurred during the time at sea, but Commander Coffin allowed her to stay aboard and become the ship's mascot. Perhaps Coffin just could not look at the loving puppy and order her ashore. Thus began the story of one of *Taney's* most beloved shipmates.

Because she had not crossed the equator, Soogie had to undergo the same humiliating initiation as the other pollywogs in *Taney's* crew. Here, she is seen being painted by three of the ship's shellbacks as part of the ritual. Apparently, Soogie accepted the treatment in the spirit intended, as there are no reports of anyone being bitten in the process.

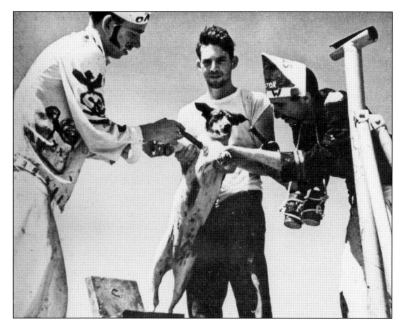

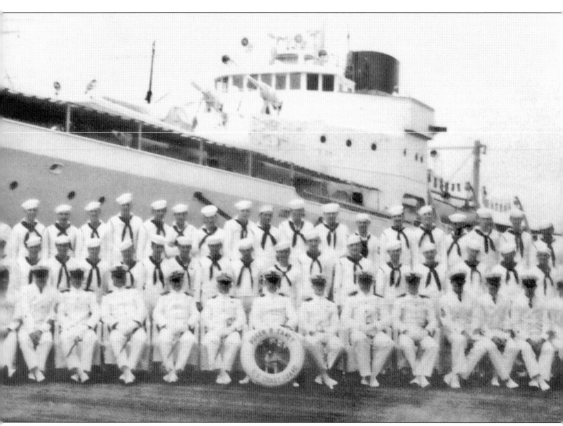

By the time this photograph was taken on August 4, 1937—Coast Guard Day, honoring the creation of the service in 1790—Soogie was a well-embedded member of the crew. In this picture of *Taney*'s plank owners, Soogie sits inside the life ring at center. This is the first known photograph of her after she joined the ship. Soogie was also well known and loved in Honolulu. She would wander the piers and the streets but always found her way back to the ship. Cab drivers who saw her on the street in town would often give her a ride back to the ship's pier.

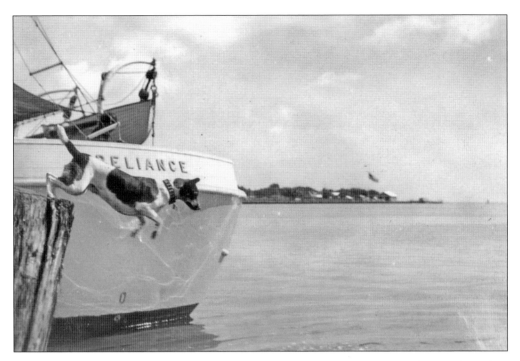

As a member of the US Coast Guard, Soogie had to be a good swimmer, and she readily took to the water whenever *Taney* was in port. Above, she is diving off the dock near the stern of the Coast Guard *Reliance*. Soogie was popular at swim parties, and was known to spend several hours in the water at a time. She also would become indignant when she was ordered out of the water to return to the ship. Below, she is shown practicing her rescue-swimmer dive.

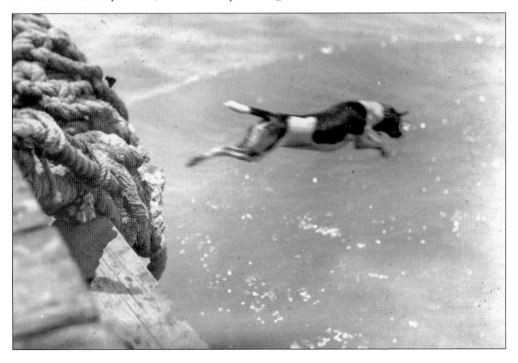

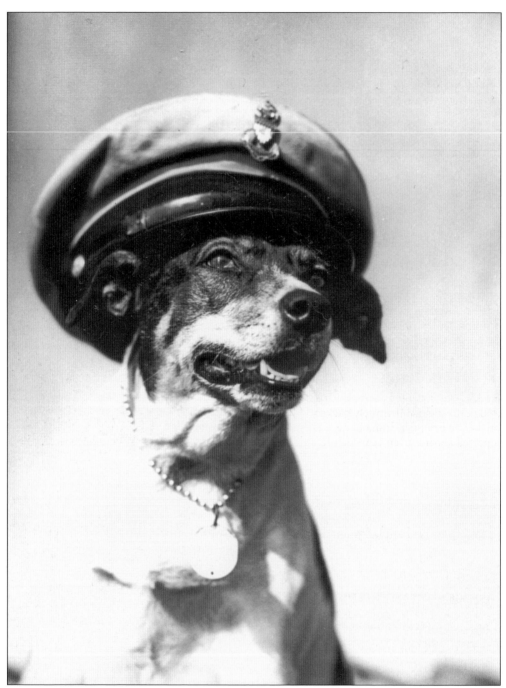

Soogie took to sea life quickly, and before long, she was an old seadog. Her advancement was fast and steady, and she quickly became a chief boatswain's mate. There are indications that Soogie's meteoric rise may have gone to her head, and she refused to stand her regularly assigned dogwatch. For this, the captain busted Soogie back to boatswain's mate first class. She retained that rank until she left the ship in 1948.

Ship's Cook First Class Fred Sims and Soogie take a breather on the port side of the main deck outside the ship's galley. *Taney* was not air-conditioned, so escaping the heat of the ship's galley was a relaxing relief. Soogie probably hung close to the galley and the mess decks to reap the rewards of scraps and under-the-table offerings.

Soogie relaxes on a beach in Tunisia after escorting a convoy in 1944. Other *Taney* crewmen in the background use the break from escort duty to enjoy swimming in the Mediterranean. Apparently, the food aboard *Taney* was agreeable to Soogie, as she had definitely packed on a few extra pounds since she reported aboard seven years before.

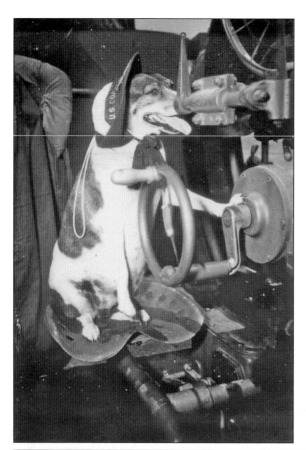

Soogie stood her share of watches alongside the rest of the crew. At left, she is at the controls of a 40-millimeter Bofors antiaircraft gun. She wears the hat of a SPAR, a woman serving in the Coast Guard. Below, she is shown manning a lookout position to aid in the navigation of the ship. There were a few places on the ship that Soogie could not go because she could not negotiate the steep shipboard ladders.

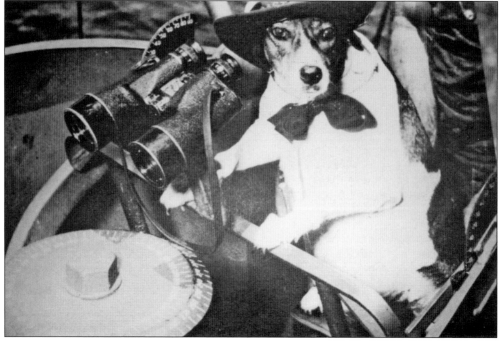

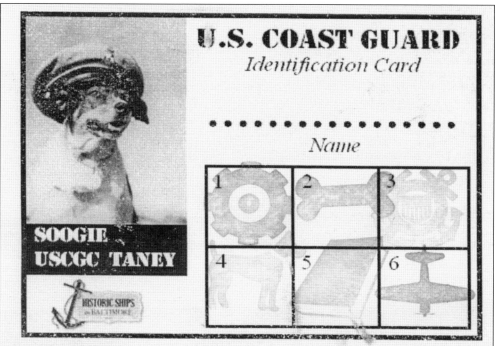

U.S. COAST GUARD
Identification Card

SOOGIE
(797-006) Name

X
Signature

Color Hair....Faint.... Eyes....Brow....
Weight....56.... Birth ...1937...
Void after....Until...revoked

R. C. Boardman

N. Nav. 548 Validating Officer

SOOGIE
USS TANEY

To make certain Soogie was readily recognized as a member of the Coast Guard, she was given enlistment papers, an official US Coast Guard identification card, and dog tags. Her assigned duties were to promote and maintain good morale amongst *Taney's* crew, which she did by occasionally chasing her tail or wandering up to an idle crewman to have her ears scratched.

U.S. COAST GUARD
Identification Card

Name

1	2	3
4	5	6

SOOGIE
USCGC TANEY

HISTORIC SHIPS
in BALTIMORE

The spirit of Soogie lives on in *Taney* today. Visitors to the *Taney* museum in Baltimore can take a self-guided tour of the ship by following Soogie's paw prints on the deck. They carry a small paper card with Soogie's picture, and stamp it at each information station that Soogie leads them to. The information stations explain different aspects of work and life aboard *Taney*.

Soogie's Coast Guard career was nearing an end when the ship returned to San Francisco after an ocean weather station patrol in 1948. She had been aboard for 11 years, longer than any other crewman. She had experienced Line Island patrols, convoy escort duty, aerial torpedo attacks, kamikaze attacks, and ocean weather station patrols. She was old and had become less tolerant of new faces aboard ship. Soogie departed the ship in 1948 with a retiring chief radioman.

42

Three

THE 1940S

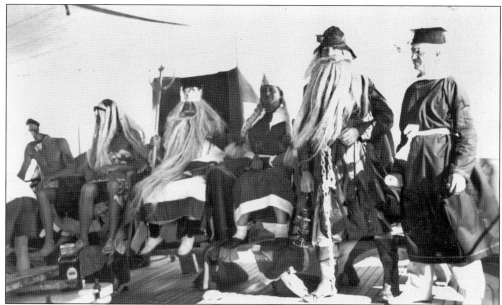

A sailor who has not crossed the equator on a ship is known as a pollywog. When they cross the equator for the first time, they undergo an initiation ceremony. The pollywogs are initiated by the shellbacks, those who have already crossed the equator and been initiated. Part of the initiation is for each pollywog to be subpoenaed before King Neptune's court, pictured here. From left to right are the royal baby, the royal daughter, King Neptune, the queen, Davey Jones, and the prosecuting attorney.

Colonists of the Line Islands, who were paid by the US government to live and work on the islands, were always pleased to see *Taney* and other cutters appear. The ships brought welcome supplies to the islands during their frequent visits. Although the ship's name by this time had been shortened to just *Taney*, the ship's boats still show the initials R.B.T.

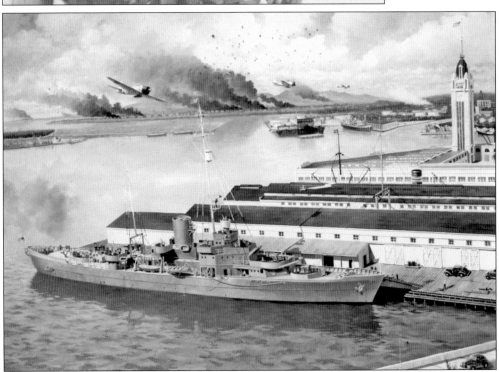

There are no known photographs of *Taney* in action on December 7, 1941. This 1989 painting by Keith Ferris shows *Taney* moored at Pier 6 in Honolulu as ships in Pearl Harbor burn in the background. She was stationed at Pier 6 to provide antiaircraft protection for the Honolulu Power Plant. *Taney* immediately went into action, firing at low-flying Japanese aircraft as they attacked targets in and around Honolulu.

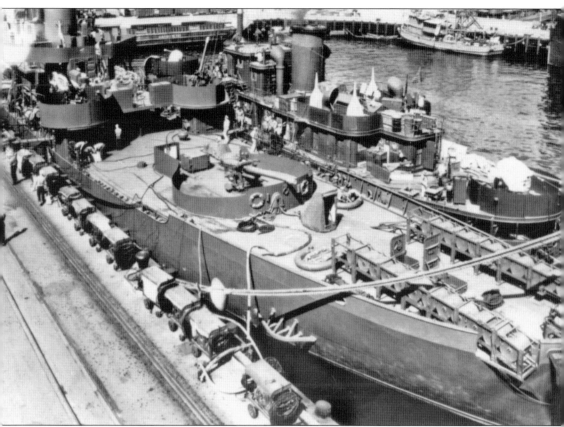

After patrolling the waters around Oahu for several months, *Taney* spent part of April and May 1942 in the Pearl Harbor Ship Yard. The .50-caliber machine guns were replaced with 20-millimeter Oerlikon antiaircraft guns. One of her 5-inch low-angle guns was removed and replaced with a third 3-inch/.50-caliber dual-purpose gun, and the latest radar was installed on the mast. The ship tied up to the right of *Taney* is the Coast Guard buoy tender *Walnut*. *Walnut* was at Midway on December 7 and immediately went to radio silence. The tender was not heard from and was presumed lost until she arrived weeks later at Pearl Harbor.

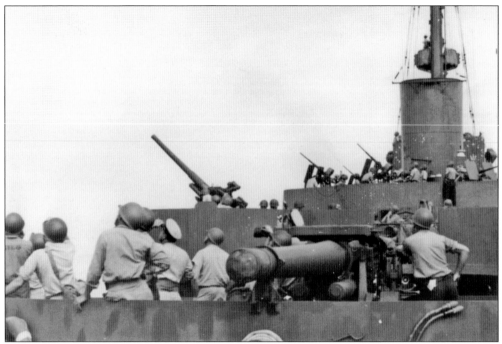

In July 1943, *Taney* was dispatched to Baker Island, a US territory on the equator, to survey the island for a possible airstrip. Not long after her arrival at the island (above), her air search radar detected a contact at 14 miles. *Taney* was soon discovered by a high-flying Japanese Mavis flying boat. She took the flying boat under fire, but the plane remained beyond the range of her guns. The Mavis dropped two bombs that straddled *Taney's* wake (below). One of the bomb splashes can be seen as *Taney* crewmen watch the plane. *Taney*, fearing the Japanese had radioed her position and called for reinforcements, quickly departed the area and headed back to Palmyra, the nearest US-occupied island.

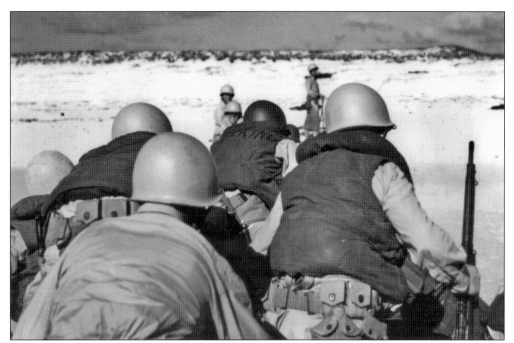

After she arranged for air support from Palmyra, *Taney* made the trip back to Baker Island two days later with an air escort for protection against Japanese aircraft. The ship landed an armed party ashore to carry out the survey work necessary to determine if an airstrip was feasible.

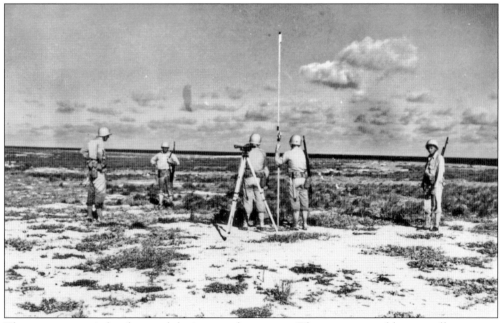

The survey team is hard at work laying out the runway. The runway would eventually measure over one mile in length. It was used as a staging area for B-24 Liberator bombers of the 7th US Air Force and P-40 Warhawk fighters of the 45th Fighter Squadron. The airstrip was in use from September 1 to November 27, 1943. It was abandoned by January 1944, when it was no longer needed because the war in the Pacific had moved farther west.

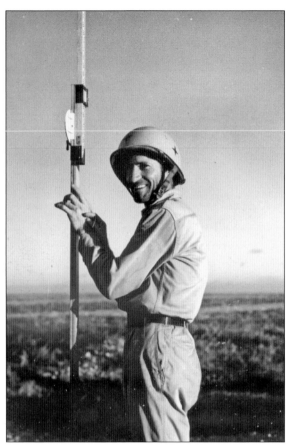

Coast Guard Machinist's Mate Lee Owen Power holds a surveying pole during the surveying operation. Power, from Yuma, Arizona, was aboard *Taney* during the Pearl Harbor attack. Even though the Baker Island airfield had been abandoned in January 1944, a loran (long-range navigation) system remained in operation on the island until 1946. A lighthouse was built on the island in 1935, and it remains there today.

Three members of the survey team move surveying equipment back to the beach in preparation for returning to the ship. The team completed the mission successfully and was able to leave the area unbeknownst to the Japanese. The lightly armed *Taney* would have been hard-pressed to defend itself and the landing party if Japanese ships had appeared at the island.

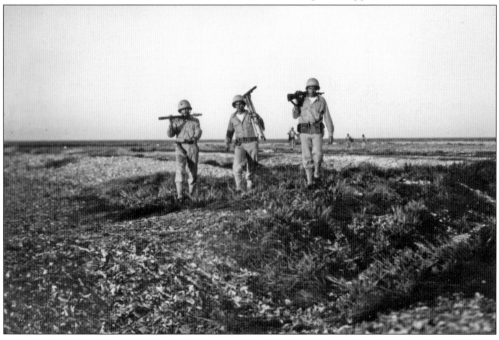

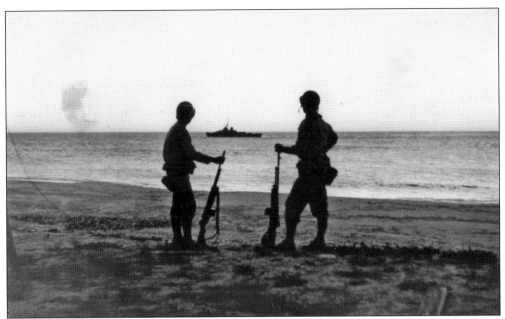

Because Baker Island did not have a suitable anchorage, *Taney* had to remain offshore in deeper water. She landed the survey team with the ship's small boats. Two members of the landing party, armed with Browning automatic rifles, watch the ship as she patrols offshore. *Taney's* crew kept a vigilant visual and radar watch to guard against the return of Japanese aircraft.

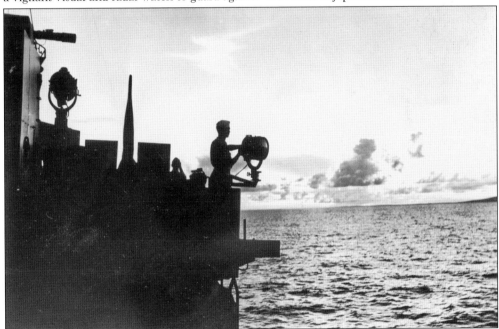

A *Taney* signalman is silhouetted against the sky as he operates the starboard signal light. Signal lights were used to communicate between ships at sea to avoid using radio transmissions that could be intercepted by the enemy. Other means of visual communications were signalmen using flags to manually spell out messages or hoisting alphanumeric flags on the ship's mast. Visual communications were especially important among convoys that needed to move undetected.

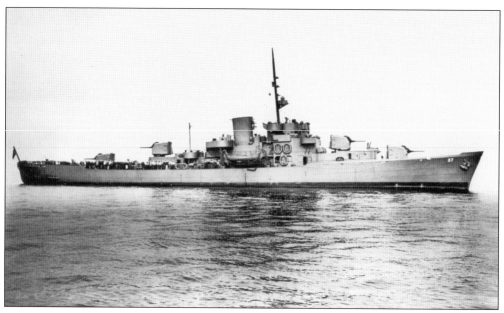

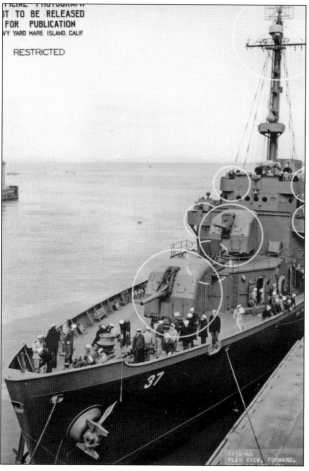

In late 1943, *Taney* was in the Mare Island Navy Yard in Vallejo, California, to have her armament upgraded. *Taney* was outfitted with four 5-inch/.38-caliber dual-purpose guns in enclosed mounts, 20mm Oerlikon antiaircraft guns, 40mm Bofors antiaircraft guns, and a hedgehog antisubmarine launcher. After leaving Mare Island, *Taney* proceeded to the East Coast. At left, *Taney* is shown tied up to a pier at Mare Island Navy Yard on February 18, 1944. The white circles on the photograph were used to identify recent modifications by the Mare Island shipyard. All the modifications were done to prepare *Taney* to become a convoy flagship. *Taney* was the only Secretary-class cutter to be fitted with four 5-inch/.38-caliber dual-purpose guns in enclosed mounts.

Taney is moored at the Mare Island Navy Yard near San Francisco. Compare this May 1941 photograph to the two on the previous page. *Taney's* appearance changed drastically in four years because of the armament added to her to carry out her mission. Such topside alterations must be carefully calculated to prevent the ship from becoming top-heavy, thereby negatively affecting her handling characteristics.

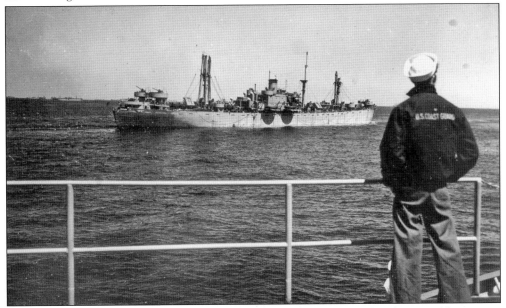

On April 2, 1944, *Taney* departed Hampton Roads as the flagship of Task Force 66 escorting convoy UGS-38, destined for North Africa. The convoy was commanded by Capt. W.H. Duvall, US Navy. UGS-38 consisted of 85 slow-moving merchant ships and two divisions of 17 escort ships. Eighteen days later, the convoy was detected by German reconnaissance planes after it entered the Mediterranean Sea. During the night of April 20, the convoy was attacked by at least three waves of low-flying German torpedo planes.

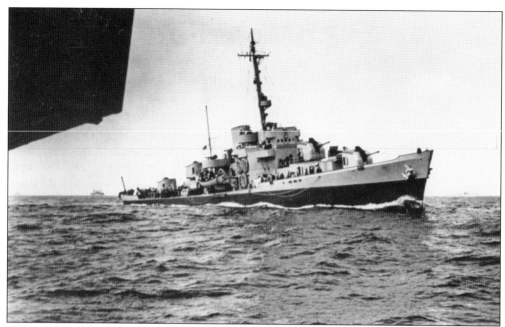

Taney is shown in Measure 21 camouflage in the mid-Atlantic while on convoy escort duty. The photograph was taken from a freighter in the convoy that had summoned *Taney's* assistance. A crewman on the freighter was in need of medical treatment, which required *Taney* to send her doctor over to the freighter. One of *Taney's* lifeboats transported Dr. Kemp H. Dowdy of the US Public Health Service to the freighter to perform surgery on the crewman. Such activity in the middle of the Atlantic Ocean is risky in peacetime but extremely dangerous in waters patrolled by German U-boats.

Taney's medical staff gets some sunshine on the ship's main deck. From left to right are Pharmacist's Mate Seaman Second Class Vern Toler; Chief Pharmacist's Mate Charles Quarles; Lt. Comdr. Kemp Dowdy, US Public Health Service; and Pharmacist's Mate Second Class Marvin Scott. The US Coast Guard did not have medical doctors of its own, so it borrowed physicians from the US Public Health Service.

Taney test fires her after two 5-inch/.38-caliber guns. *Taney* was the only Secretary-class cutter to be equipped with four of these guns in enclosed mounts, which made her appear more like a destroyer than a cutter. The 5-inch/.38-caliber guns were dual-purpose weapons, meaning they could be used against surface and air targets. The gun could be elevated to 85 degrees to engage aircraft. It had an effective range of up to 18,000 yards and could fire 15 rounds per minute.

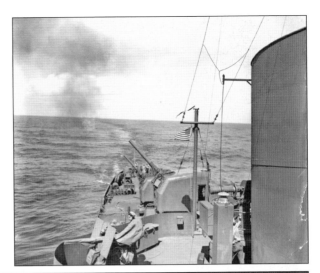

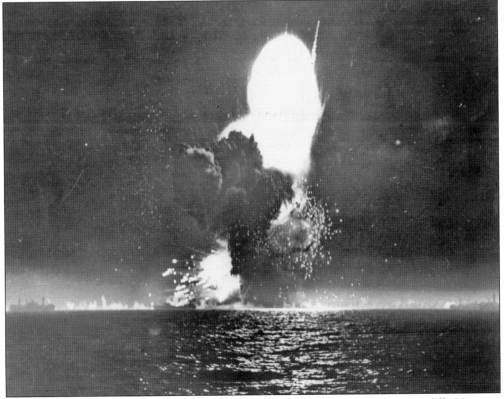

The Liberty ship SS *Paul Hamilton* was on her fifth war voyage en route from Norfolk, Virginia, to Bizerte, Tunisia, as part of convoy UGS-38. The convoy was near Cape Bengut, Algeria, when it was attacked on the night of April 20, 1944, by low-flying Luftwaffe torpedo planes. *Paul Hamilton*, which was carrying high explosives and US Army Air Corps personnel, was struck by a torpedo and disintegrated. The explosion killed everyone onboard, including 471 Army personnel, 29 Navy guards, and 47 merchant mariners. Three more merchant ships were damaged, one of which later sank, and one US Navy destroyer, the USS *Lansdale*, was sunk. *Taney* was narrowly missed by two aerial torpedoes but emerged from the battle unscathed.

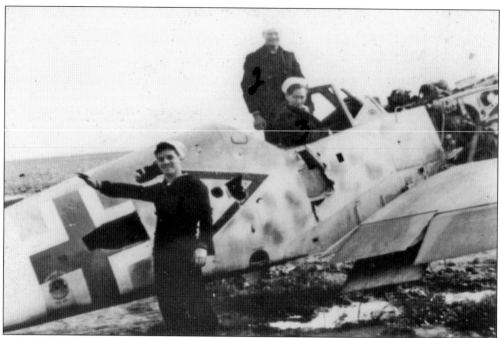

Three *Taney* crewmen pose with a damaged Messerschmitt Bf-109 fighter of the Luftwaffe in Tunisia. The Bf-109 was a frontline fighter from 1937 to 1945. Considered one of the most advanced fighters of its time, it first saw action during the Spanish Civil War and continued in service with the Spanish Air Force until December 1965. The aircraft in this photograph is painted in desert camouflage.

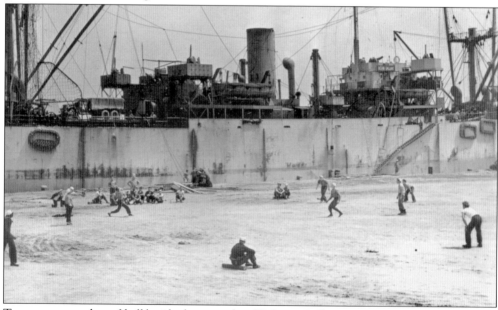

Taney crewmen play softball beside the cargo ship SS *Ocean Gallant* in North Africa after escorting a convoy across the Atlantic Ocean. Baseball and softball were popular off-duty activities among American servicemen in the United States and abroad. The lack of gloves and mitts did not stop these men from getting a game started. All they needed was a ball and a bat.

Lt. CluFlu Lusk stands by as crewmen are given instructions in the use of the M1903 Springfield bolt-action rifle. The versatile rifle saw extensive service in World War I and was still being used at the beginning of World War II. Its use aboard ship was limited to landing parties and exploding floating mines. It was eventually replaced by the M1 Garand semiautomatic rifle, but it was still used as a sniper rifle in the early years of the Vietnam War.

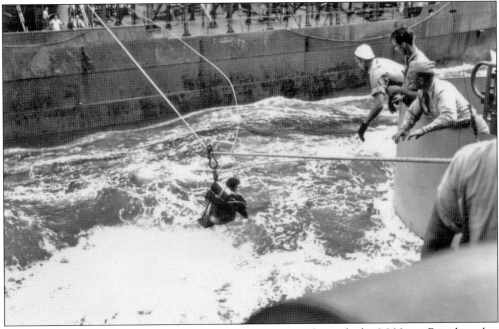

During convoy escort duty in September 1944, *Taney* came alongside the 9,900-ton British tanker *Empire Wordsworth* for a highline transfer. British merchant seaman George Hempenstall was in need of medical treatment that could not be given on the tanker. *Taney*'s doctor, Lt. Comdr. Kemp Dowdy, observes the transfer from a gun tub. Dowdy performed the necessary surgery on Hempenstall, and he was later transferred back to the tanker.

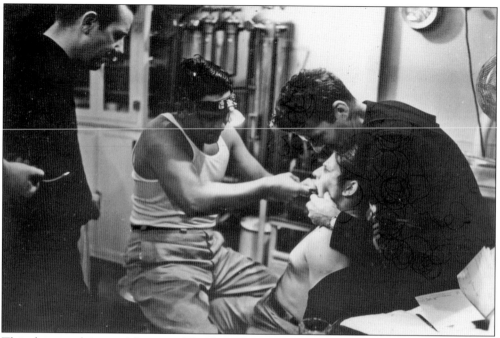

This photograph is painful to view. The ship's doctor appears to be extracting a tooth from what appears to be one of the ship's officers. Although the ship had a doctor aboard and a well-equipped sick bay, there were some medical procedures that just had to be done ad lib.

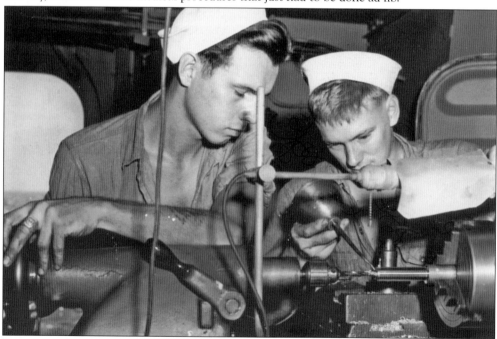

Here is another delicate operation performed aboard *Taney*, but this one is not as painful as the one in the previous photograph. Two machinist's mates use a lathe to drill a piece of steel stock in the ship's machine shop. Note that neither man is using protection to prevent being struck in the eye by a metal shaving. Such a practice would not be permitted on board ship today.

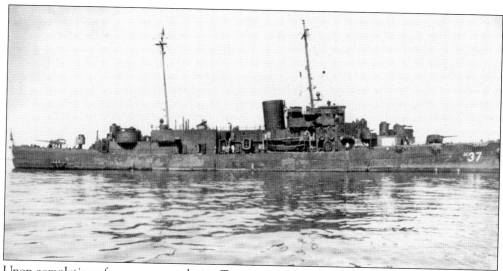

Upon completion of convoy escort duties, *Taney* was converted to an amphibious command ship at the Boston Navy Yard, as seen here in September 1945 in Japan. The four enclosed 5-inch/.38-caliber guns were removed and replaced by two 5-inch/.38-caliber open gun mounts. She would also carry three twin 40-millimeter Bofors antiaircraft guns and four 20-millimeter Oerlikon antiaircraft guns. She was fitted with accommodations for an admiral and his staff and enhanced communications and radar facilities. The ship's designation was changed to WAGC-37, and she was reassigned to duties in the Pacific theater.

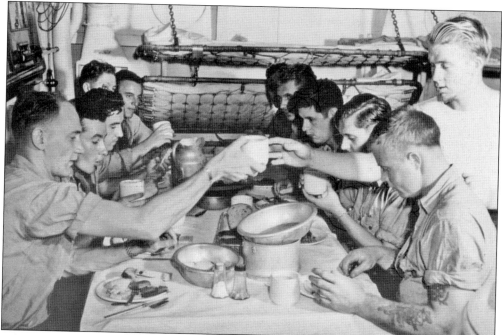

When *Taney* was converted to a convoy flagship and later to an amphibious command ship, her complement was increased to 280 men. Originally built to accommodate a crew of 130, *Taney* was now crammed to the maximum. Space was so critical that it was necessary to have men sleep on the mess deck. Here, members of the crew eat on the enlisted men's mess decks. Note the sleeping bunks attached to the far bulkhead.

Mess cooking is one of the least glamorous duties aboard Coast Guard and Navy ships. Mess cooks are usually nonrated men who have recently reported aboard. They actually do little or no cooking. Mess cooks serve the food to the crew, clean the galley and the mess decks, clean the mess trays, pots, and pans, and perform other duties at the direction of the ship's cook. Here, mess cooks present their hands as they are inspected for cleanliness.

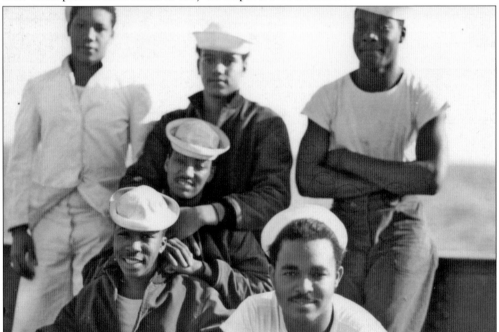

A group of black crewmen gather on deck. During World War II, blacks usually served in lowly positions like cooks or stewards for the wardroom. The Coast Guard was the first of the US military services to integrate. In 1944, Coast Guard Lt. Carlton Skinner commanded an integrated crew aboard the cutter *Sea Cloud*, a sailing ship assigned to a weather station. Skinner proved that the integrated crew worked as efficiently, if not better, than a segregated crew.

Two crewmen make ice cream aboard ship. Ice cream was understandably a treat for the crew. Another way to get ice cream was to rescue downed flyers. When a ship fished a flyer out of the water, she had to rendezvous with the aircraft carrier to affect a transfer. Before high-lining the flyer to the carrier, the rescuing ship demanded ice cream be high-lined to her first. The rank of the flyer was used to determine the amount of ice cream demanded—the higher the rank, the larger the quantity.

Machinist's Mate Lee Owen Power gives a razor cut to another *Taney* crewman while others wait their turn. Haircuts were usually given by a crewman who had some previous barber experience or someone who wanted to be a barber. Power was a farmer with no previous barbering experience. As long as haircuts met military regulation, the style and appearance were not important.

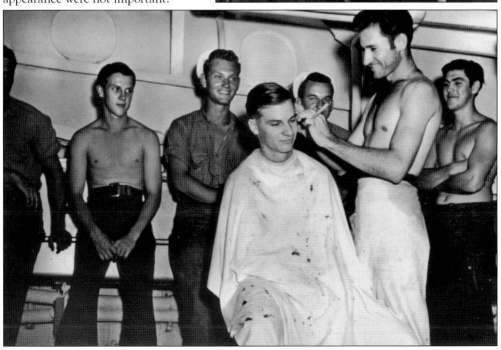

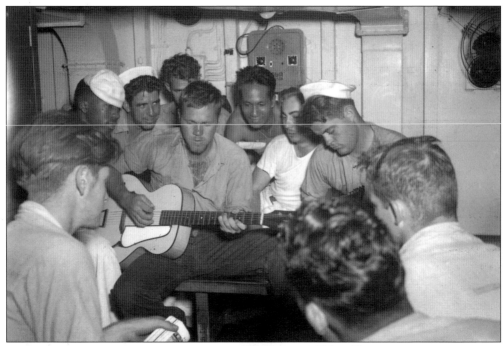

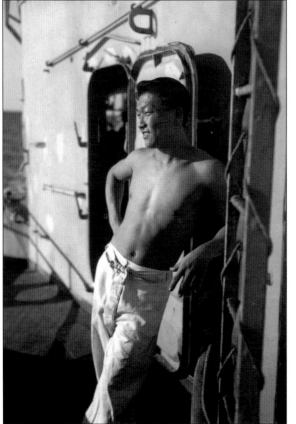

Off-duty *Taney* crewmen enjoy an impromptu music session in the ship's mess deck during convoy duty in 1944. Captured by *Taney* crewman Verne Toler, this picture illustrates well how Americans of all backgrounds served in the Coast Guard. The peak strength of the service, experienced during World War II, was 240,000 men and women, most of whom were volunteers who served all over the world at sea and ashore.

Taney crewman Steward's Mate Second Class Paul Y.S. Moon of Kapaa, Kauai, Hawaii, is pictured while off duty during Mediterranean convoy duty in 1944. Many Coast Guardsmen from Hawaii who served aboard *Taney* were of Asian heritage.

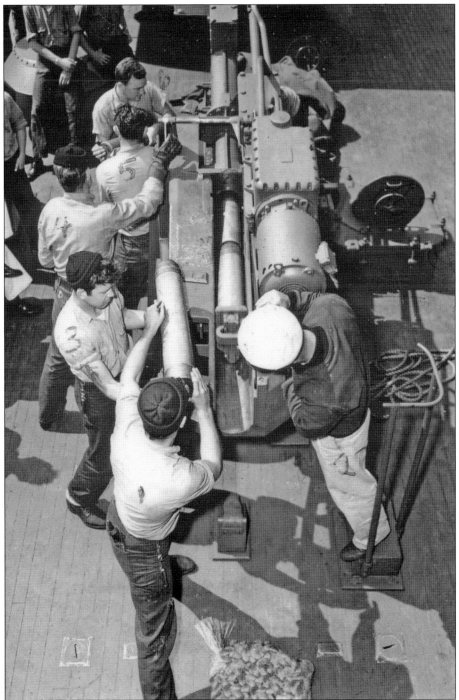

Crewmen gather around a training simulator for the 5-inch/.38-caliber gun. The simulator, known as a loading machine, was used to train gun crews in handling ammunition and loading the gun without actually putting a round into the real gun. It was useful in training green crewmen who had never loaded a gun before and providing refresher training for experienced gunners after a long yard period. It was also necessary for maintaining proficiency and maximum rate of fire.

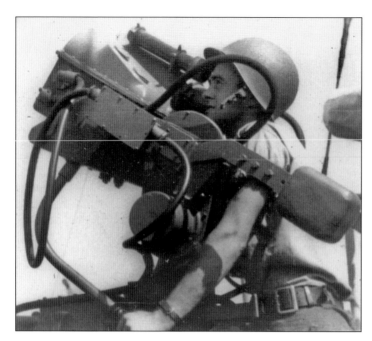

A crewman operates a Mark 51 gun director that guides the 40-millimeter Bofors antiaircraft gun. The gun director operator centers the target aircraft in the sight and locks on to it, then sends information through a primitive computer to the gun so the crew can properly lead the target. Without a gun director, the gun crew would have to manually sight and track a target aircraft.

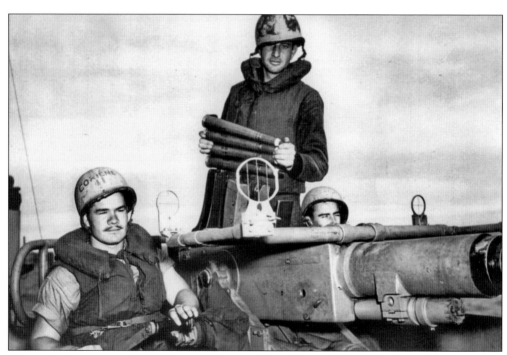

Three crewmen man a 40-millimeter Bofors antiaircraft gun. This is the Army version with a single barrel. It was usually mounted on four wheels so it could be easily moved on land. Because of a shortage of twin-barrel 40-millimeter Bofors, this gun was modified so it could be mounted on *Taney's* deck. It was there only a short time before it was replaced by a twin-barrel mount. From left to right are Seaman Second Class Charles Longuevan, Seaman First Class Earnest C. Lincoln, and Seaman Second Class Donald H. Campbell.

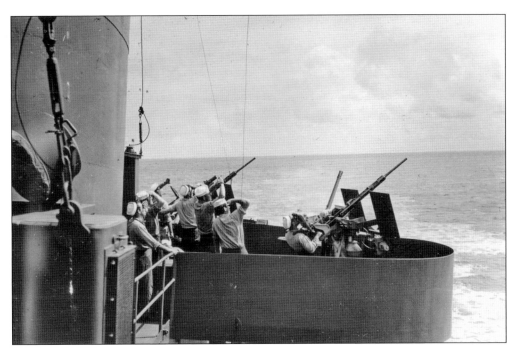

Gun crews shade their eyes against the sun as they watch US planes make simulated attacks on *Taney*. Such attacks provided pilots with valuable training in attacking ships. It was also valuable training for shipboard gun crews in repelling air attacks, especially during the latter part of the war, when they faced kamikaze attacks. Below, US Navy planes make training runs on *Taney*. Note the K-gun depth charges in the foreground. They were the primary weapon against submerged enemy submarines.

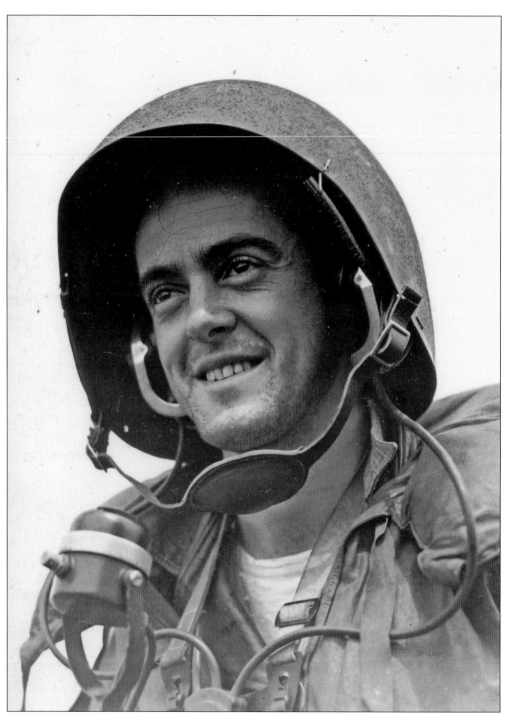

Internal communications are key to a ship operating efficiently. Each part of the ship is linked by a sound-powered phone system. During battle conditions, clear and concise communications are a must. The member of a gun crew responsible for sending and receiving messages was called the talker. The talker wore a sound-powered headset that makes wearing a standard helmet impractical. Therefore, talkers wore oversize helmets to fit over the communication gear.

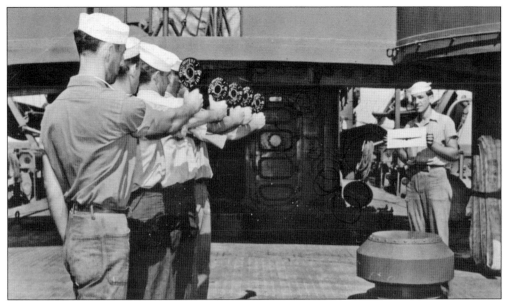

Aerial gunners had an important job in the defense of the ship. These gunners are holding a training device for the 20-millimeter Oerlikon antiaircraft gun. They are looking through the training gun sight at the aircraft silhouette being held by the instructor. The gunners are learning how the aircraft fills the gun sight to determine at what range to open fire on the target.

Taney gunners Virgil Clark, Salvatore Princeotto, and Earl Kirby admire a pin-up on the side of one of *Taney's* 5-inch/.38-caliber guns. Pin-up girls were very popular among servicemen in World War II. Servicemen hung them in Army barracks and in lockers aboard ships to boost morale. They were also used as nose art on US Army Air Corps bombers and fighter planes in both the Pacific and European theaters.

Five crewmen from the Los Angeles area pose on the barrel of one of *Taney's* 5-inch/.38-caliber guns while the ship is operating in the Pacific Ocean in 1945. From left to right are Robert H. Hutchason, Richard H. Phillips, Charles Longuevan, John N. McCafferty, and Louis Marino. Servicemen from the same hometown often had their picture taken together so the photograph could appear in their hometown newspaper.

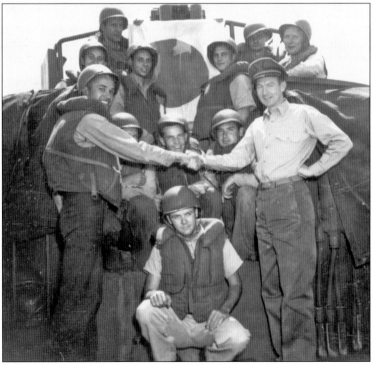

Commanding officer Comdr. George D. Synon congratulates the aft port 40-millimeter Bofors antiaircraft gun crew after they shot down a Japanese suicide plane at Okinawa in 1945. Synon is shaking the hand of Ralph Slapper, who fired the shots that downed the kamikaze. Synon was the commanding officer of *Taney* from November 1944 to August 1945 and again from December 1951 to January 1953.

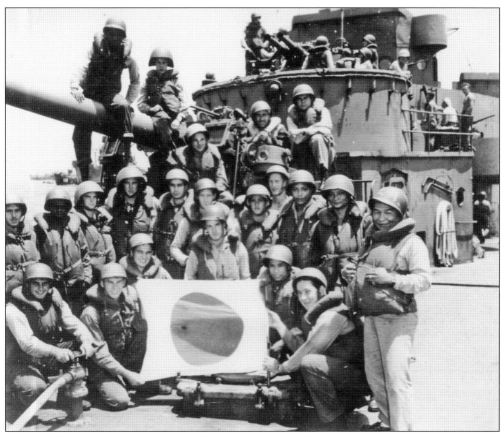

Taney's victorious gun crews gather around one of the ship's 5-inch/.38-caliber mounts. The ship shot down five Japanese aircraft in the Okinawa campaign. The Japanese flag they are holding was taken from a Japanese pilot who was shot down. A dual 40-millimeter Bofors antiaircraft gun mount is on the next deck above in front of the bridge.

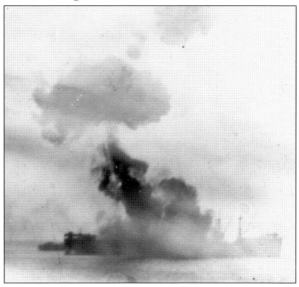

On May 28, 1945, Navy fleet tug USS *Takasta* (AT-93) was towing the damaged minesweeper USS *Spectacle* (AM-305) near Okinawa. *Takasta* fired at a flight of four Japanese suicide planes, shooting down one. The damaged suicide plane managed to hit the Victory ship SS *Brown Victory* on the way down. This photograph was taken off *Taney's* port bow at the instant the plane hit. Three US Navy armed guards and one merchant seaman were killed and 18 others were wounded in the attack. *Brown Victory* remained afloat and was able to deliver her cargo to Saipan.

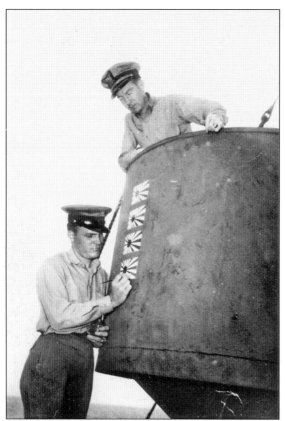

Chief Quartermaster Charles F. Odam paints Japanese flags on the side of *Taney*'s bridge while the ship's captain, Comdr. George D. Synon, looks on. The flags represent four Japanese planes *Taney* shot down during the Okinawa campaign. Kill, or victory, markings were often used on US Coast Guard and Navy ships, but, with limited exceptions, were not permitted on US Navy aircraft. Kill markings were more commonly used on fighter and bomber aircraft of the US Army Air Corps.

Entertainer Dennis Day and *Taney*'s commanding officer, Commander Synon, are pictured aboard *Taney* in 1945. Day was a singer who was best known for his association with Jack Benny. At the time of the photograph, Day was traveling with a USO group entertaining US servicemen in the forward area of the Pacific offensive. Dennis Day also served as a lieutenant in the US Navy from 1944 to 1946.

Coastguardsman Jack Dempsey came aboard *Taney* in 1945. Dempsey, a world-famous professional boxer, was the world heavyweight champion from 1919 to 1926. In the Coast Guard, Dempsey served as director of physical education. He also served aboard three auxiliary transports.

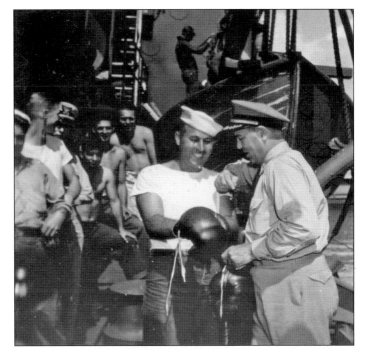

Commander Synon salutes as Navy Rear Adm. Calvin H. Cobb welcomes Army Gen. Joseph W. "Vinegar Joe" Stillwell aboard at Okinawa in 1945. General Stillwell had been chief of staff to Generalisimo Chiang Kai-shek in the China-Burma-India theater. Near the end of the Okinawa campaign, he commanded the US 10th Army. After the war, Stillwell commanded the US 6th Army at the Presidio in San Francisco.

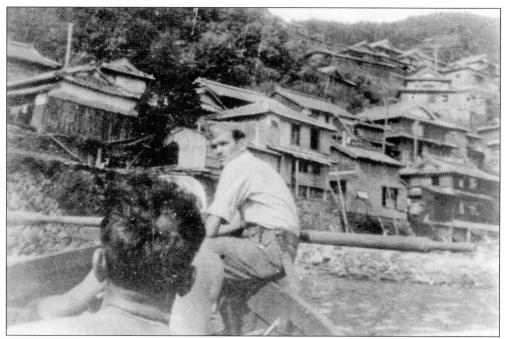

On September 11, 1945, nine days after the surrender was signed aboard USS *Missouri*, *Taney* anchored in Wakandura Wan, Honshu, Japan. The next day, four officers and seven enlisted men departed the ship to go ashore by small boat to procure a hotel to serve as quarters for Allied prisoners of war. Some of the *Taney* crewmen were assigned to stand guard with Japanese policemen at the hotel.

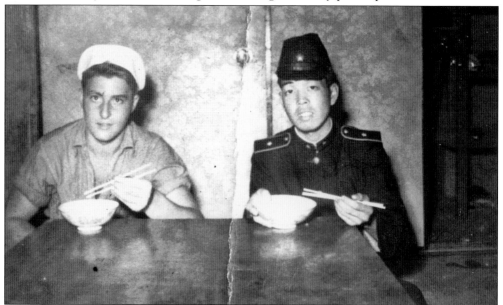

Taney crewman Seaman First Class Alfred C. Haese of Greenleaf, Wisconsin, and a young Japanese policeman appear to be at ease as they eat a bowl of rice at a Japanese hotel. Although uneasy at first about such an assignment, the *Taney* crewmen found the Japanese polite and hospitable. The movement of the prisoners of war was meant to get them away from the deplorable camp conditions and into better accommodations so they could be examined and treated before being sent home.

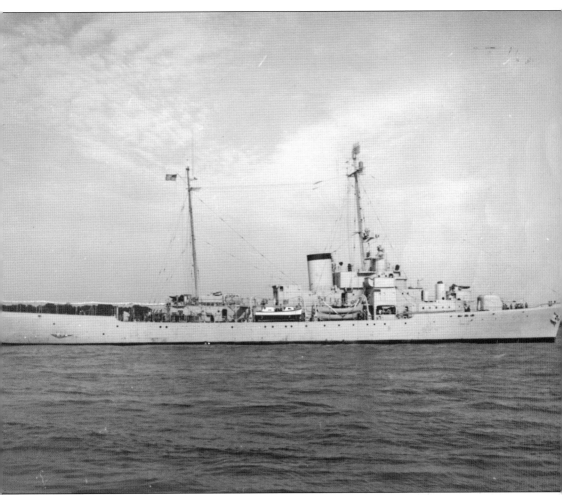

In 1946, *Taney* underwent yet another major re-conversion, this time in the Charleston Navy Yard in South Carolina, to change from a fighting warship back to a peacetime Coast Guard cutter. Deckhouses that were added for amphibious command ship duties and most of her armament were removed. She retained one enclosed 5-inch/.38-caliber gun on the bow, a hedgehog antisubmarine weapon, and one twin 40-millimeter Bofors antiaircraft mount. She was again painted Coast Guard white and redesignated WPG-37.

While the ship was in the Charleston Navy Yard in 1946 for peacetime conversion, this group of *Taney* crewmen gathered near the ship for a photograph. They were all that was left of the ship's World War II crew. Many of their shipmates had gone home or transferred to other ships. These men had been together on Line Islands patrol, convoy escort duty, and amphibious operations at Okinawa. They were waiting to be discharged based on a points system.

Taney rolls hard to starboard in this 1948 view on weather patrol in the Pacific Ocean. Much of *Taney*'s duty after the war until 1950 was spent on ocean weather station patrol. In heavy seas, it was important for *Taney* to keep her bow pointed into the wind so that she could ride the waves. Failure to do so could result in the ship being caught broadside to the swells and run the risk of capsizing.

Four

THE 1950S

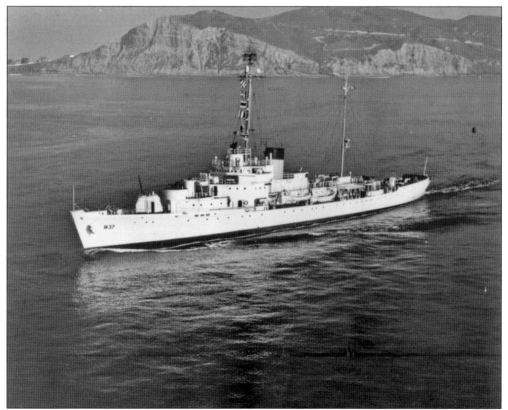

Taney cruises off Point Lobos, California, during the Korean War. *Taney* did not participate directly in the war the way she did in World War II. Instead, she was assigned to weather stations and plane guard and air rescue stations near Midway and Adak, Alaska. After the start of the Korean War, antisubmarine weapons such as depth charge racks, K-guns, and sonar were restored. During the war, the United States moved a large number of troops to Korea by military transport aircraft, which necessitated Coast Guard cutters being stationed along the air routes as navigation aids and plane guards.

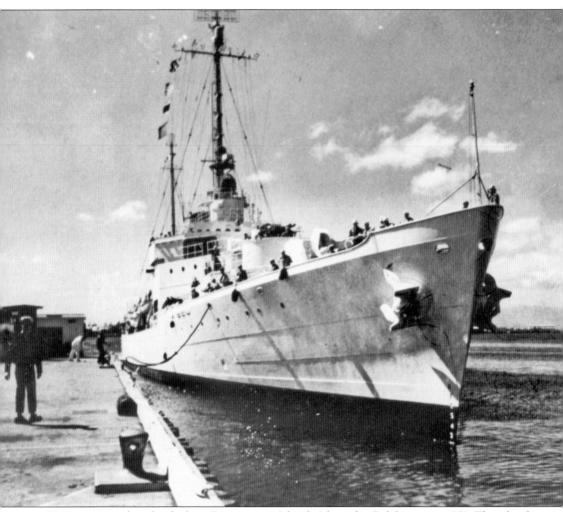

Taney is moored to the dock at Government Island, Alameda, California, in 1951. The island is one of the largest Coast Guard facilities on the West Coast. It was formed by a dredging operation in 1913, and from 1942 to 1982, it housed the Coast Guard's boot camp. Later renamed Coast Guard Island, it was *Taney's* homeport from 1946 to 1972.

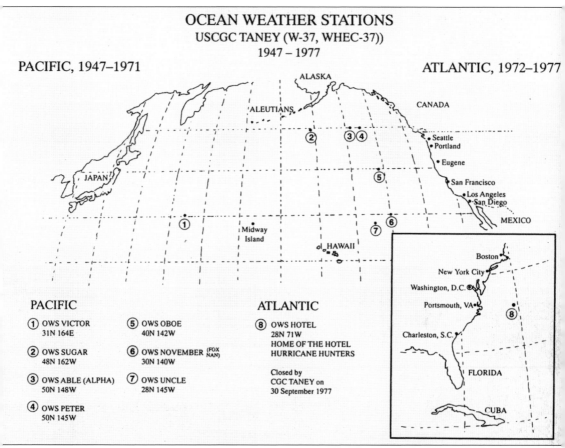

OCEAN WEATHER STATIONS
USCGC TANEY (W-37, WHEC-37))
1947 – 1977

PACIFIC, 1947–1971 ATLANTIC, 1972–1977

PACIFIC

① OWS VICTOR
31N 164E

② OWS SUGAR
48N 162W

③ OWS ABLE (ALPHA)
50N 148W

④ OWS PETER
50N 145W

⑤ OWS OBOE
40N 142W

⑥ OWS NOVEMBER (FOX NAN)
30N 140W

⑦ OWS UNCLE
28N 145W

ATLANTIC

⑧ OWS HOTEL
28N 71W
HOME OF THE HOTEL
HURRICANE HUNTERS

Closed by
CGC TANEY on
30 September 1977

Taney participated in ocean weather station patrols off and on from 1948 to 1977. Ocean weather stations were placed along heavily traveled air routes and shipping lanes. These are the ocean weather stations patrolled by the US Coast Guard. Ocean Station Victor was the farthest station. It was almost equal distance from Hawaii and Japan. Because of this, *Taney* would pull double Victor duty, which meant three weeks on Station Victor, and upon relief by another cutter, she went to Japan for rest and relaxation, then she returned to Station Victor for three weeks before going back to Hawaii. (Brian J. Whetstine.)

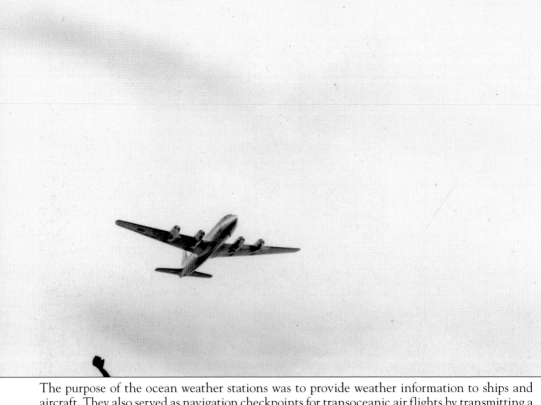

The purpose of the ocean weather stations was to provide weather information to ships and aircraft. They also served as navigation checkpoints for transoceanic air flights by transmitting a homing signal on a designated frequency. This United Airlines Douglas DC-6 passes over *Taney* along the air route between Hawaii and California. Cutters also served as mid-ocean rescue stations. In 1956, the cutter *Pontchartrain* rescued all 31 persons from a Pan American airliner that ditched beside the ship because of engine trouble. *Pontchartrain* was patrolling Ocean Station November at the time.

On July 2, 1953, while patrolling off the coast of Alaska, *Taney* was dispatched to search for a downed Martin PBM Mariner flying boat from Navy Patrol Squadron 42. The aircraft had sent a distress message reporting that it had an engine fire near Adak, Alaska. The plane crashed in bad weather. *Taney* proceeded to the scene and searched the area in heavy fog. She located the wreckage and hoisted these two pontoons aboard. There were no survivors among the 12-man crew. *Taney* recovered only one body.

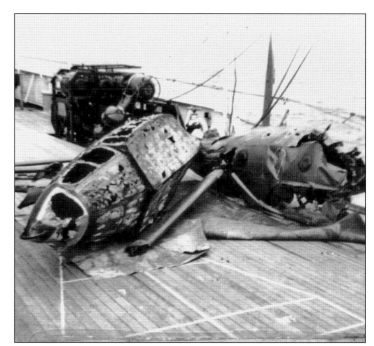

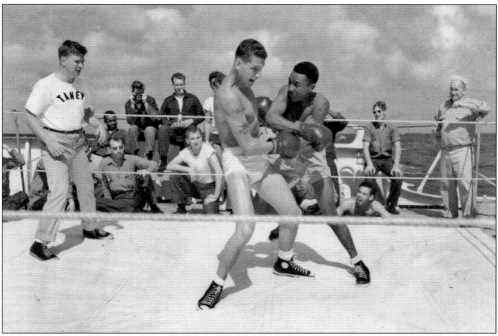

Pacific Ocean stations took anywhere from a few days to two weeks to reach. The station was a 10-mile square that the ship would remain in for three weeks. Long hours of working and watch standing were boring and fatiguing for the crew. Midway through the three-week patrol, *Taney's* crew would stage a day of fun and relaxation called "Hump Day." The crew came up with numerous ways to exploit Hump Day to the maximum, such as this boxing match among shipmates. Watching the match at far right is Chief Boatswain's Mate Alva C. "Pappy" Haynes, a legendary crewman who ran the deck department on *Taney* from 1946 to 1950.

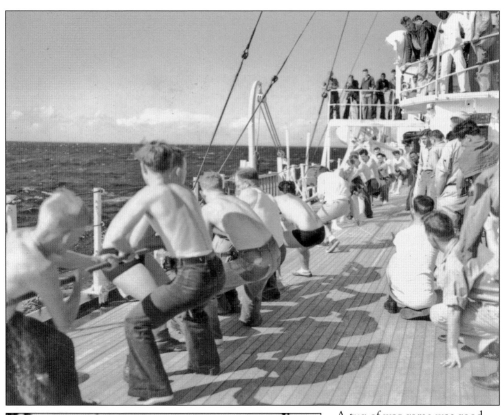

A tug-of-war game was good
training for the ship's line
handlers. Teams of six to eight
men competed along the port
side of the main deck with
one of the ship's mooring
lines. To make the game more
interesting, a fire hose was used
to wet the ship's wooden deck.

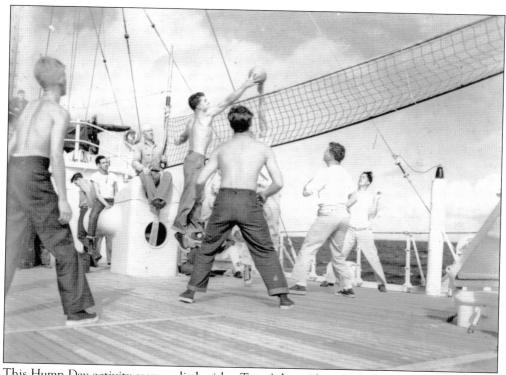

This Hump Day activity seems a little risky. *Taney*'s beam (maximum width) was only 41 feet amidships. These men are playing volleyball at a narrower section of the ship near the stern. Care was needed not to hit the ball overboard, or it was game over. Note the crewman sitting on the towing bitt holding the upright support for the net.

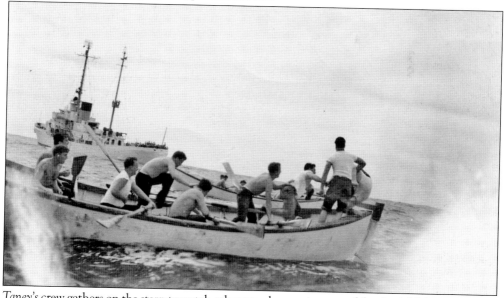

Taney's crew gathers on the stern to watch other members racing two of the ship's 26-foot Monomoy boats. Monomoy boats were originally built for the numerous Coast Guard life-saving stations along the US coast. The boats were about eight feet wide and weighed nearly a ton. They were designed to be rowed from shore through rough surf to rescue people in distress close to shore.

Deck shuffleboard scoring zones were marked on the port side of *Taney's* main deck near the end of the superstructure. Tournaments between teams were held on Hump Day, but this activity could also be enjoyed by off-duty crewmen any time as long as the weather conditions permitted. It appears that the rules may have been bent a bit to accommodate the limited space available. The regulation distance of a deck shuffleboard court is 39 feet.

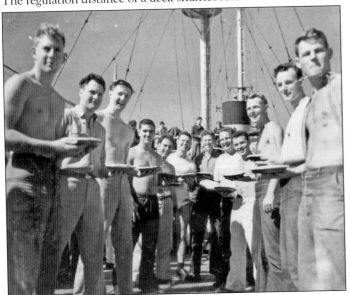

A pie-eating contest is always an entertaining event. Here, 12 members of the crew hold the pies specifically prepared for the event. Cooks were sure to get a thin crust and a lot of messy filling. There were two ways to win a pie-eating contest: in one, the contestant who finishes first wins, and in the other, the contestant who eats the most pie in 15 bites wins.

With hands behind their backs, the contestants dig in as they gulp down the pies. Keeping the pie pans in front of them on a smooth wooden deck was a challenge for the pie eaters. The winner appears to be the man in the white pants left of center. His pie pan looks the cleanest. Obviously, the messier the pie, the more entertaining the event was for the crew. In this contest, even the losers are winners by having the opportunity to eat a whole pie.

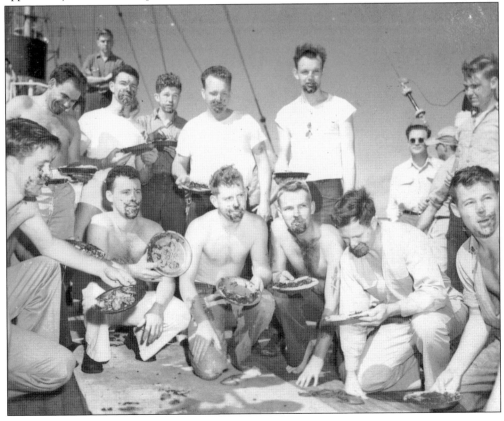

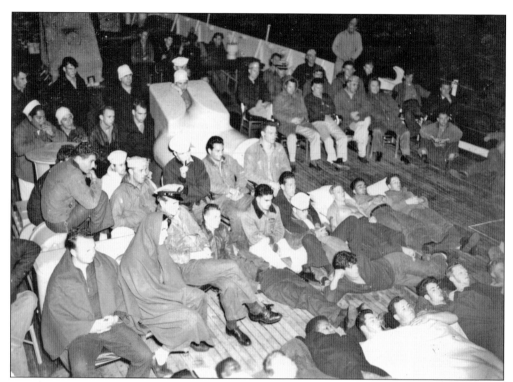

Another way to break the monotony and boredom of ocean station duty was a variety show. Members of the crew who were able to play musical instruments were among the favorites. Skits with crewmen dressed in outrageous makeshift costumes were also popular. Above, the crew lounges on the quarterdeck near the stern as they watch a variety show. Below, crewmen use a guitar, a violin, and an accordion to accompany the crewman singing. The entertainment did not need to be good to be amusing to the crew.

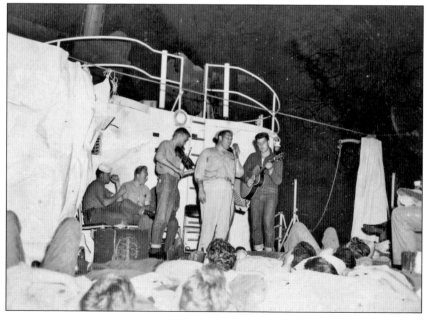

The explosion of the first hydrogen bomb on March 1, 1954, in the Bikini Atoll is pictured. Codenamed Castle Bravo, this was the largest atmospheric nuclear explosion ever detonated by the United States and was several times more powerful than had been predicted. Heightened publicity over radioactive contamination, especially after a Japanese fishing crew was harmed by fallout, ramped up international tensions, especially between the United States and Japan. *Taney* had been commissioned while atomic devices were only dreamed of by a few scientists, but the Cold War and the nuclear age brought a new chapter in the ship's history of service to the country.

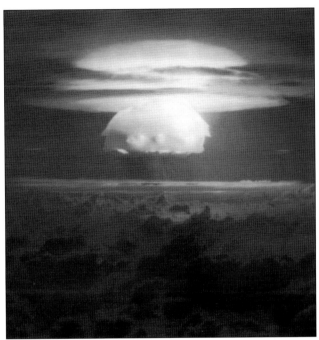

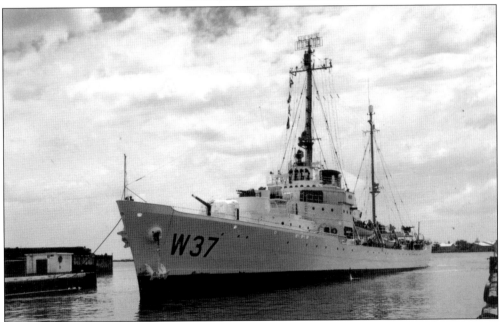

Taney arrives at Pier 9 in Honolulu in 1955. In the wake of the Castle Bravo nuclear controversy, the cutter was temporarily released from 12th Coast Guard District operations and placed at the disposal of the Atomic Energy Commission. In February 1955, *Taney* departed San Francisco with a team of nuclear scientists and oceanographers aboard, and for the next six weeks transited the Pacific to survey residual radiation from the blast. After departing Hawaii on the first leg, *Taney* steamed to the Marshall Islands, the Philippines, Okinawa, and finally Japan collecting water, plankton, and fish samples, while scientists measured radiation. After the *Taney* scientific party conferred with their counterparts in Japan, the worst fears about residual radiation were put to rest.

Officers sharpen their skills in the use of a sextant. A sextant is used to measure the angle between a celestial object and the horizon to aid in determining a ship's position. Improved methods such as the use of loran (long-range navigation) and GPS (Global Positioning System) have lessened the need for using a sextant at sea. However, the use of a sextant is still important in case of failure of the electronic systems.

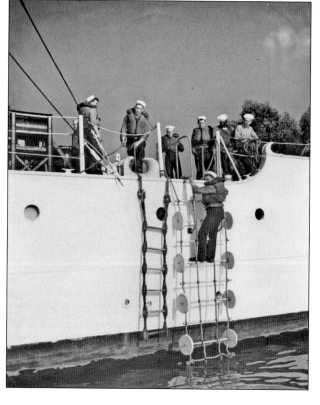

Crewmen train on a Jacob's ladder on the port side near the stern of the ship. The ladder is used for boarding and un-boarding the ship while at sea. It provides easy access to a small boat or raft alongside. In heavy seas, using the ladder could be challenging, so the crew practices ascending and descending the ladder to ensure it is proficient in its use.

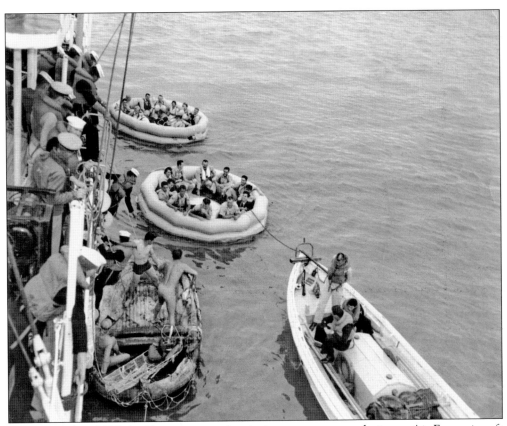

Coast Guard and US Air Force personnel train in at-sea rescue techniques. Air Force aircraft routinely transport military personnel and dependents over the ocean to US bases abroad. Therefore, Air Force flight crews must be familiar with Coast Guard rescue procedures in case the aircraft is ditched at sea. The training also benefits *Taney's* crewmen in handling personnel who are not familiar with boarding a ship on a Jacob's ladder.

Coast Guard ships are always on the alert for distress calls from aircraft and ships. One of *Taney's* motor whaleboats returns to the ship after coming to the aid of a disabled fishing boat. In this case, the water is calm, but Coast Guardsmen must be prepared to come to someone's aid regardless of the weather. Training in such scenarios is an ongoing part of Coast Guard life.

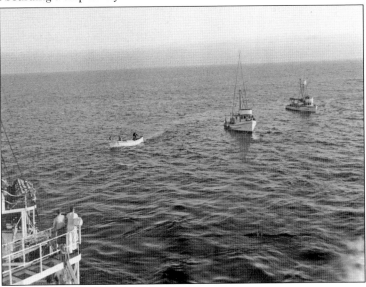

Taney crewmen sit in one of the ship's boats. The boats are used to rescue people in the water, to approach vessels in distress, to approach and board vessels to be searched during law enforcement operations, and to transport personnel to and from shore. The boats are also used as the ship's lifeboats. Training in boarding, lowering, and raising the boats, both at sea and in port, is necessary to maintain crew efficiency in the operation.

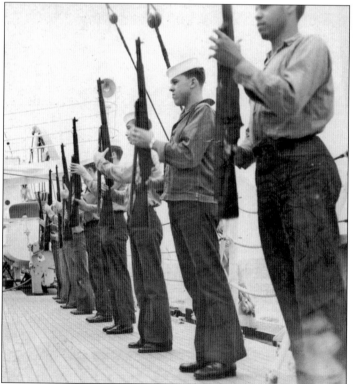

Crewmen are at "present arms" as they train in the manual of arms with M1 Garand rifles on *Taney's* main deck. The manual of arms is not a usual shipboard routine. These men are most likely members of the ship's honor guard. The honor guard would usually only stand for a VIP visit, a change of command, or another formal event.

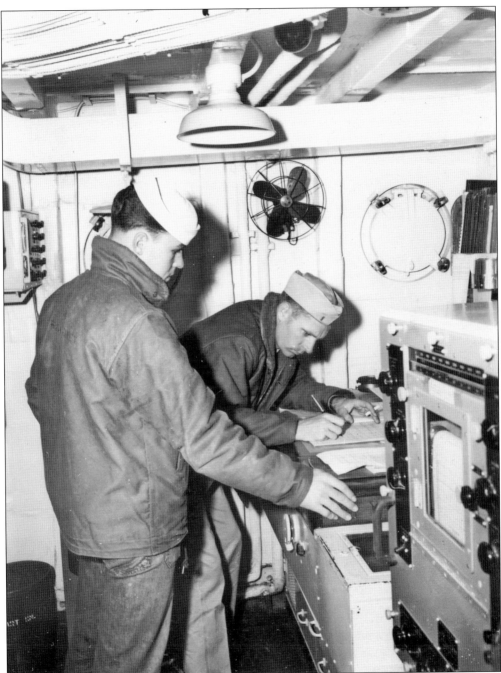

In *Taney's* chart room, an officer makes an entry in the ship's deck log as a quartermaster watches. The deck log is an official record, divided by watch periods, of the important circumstances and occurrences aboard ship. It is a legal document that also creates a historical record of the ship. Engineering logs, navigation logs, radio logs, and signal logs are just some of the many logs maintained aboard ship. At lower right is the ship's depth finder, used to measure the depth of the water.

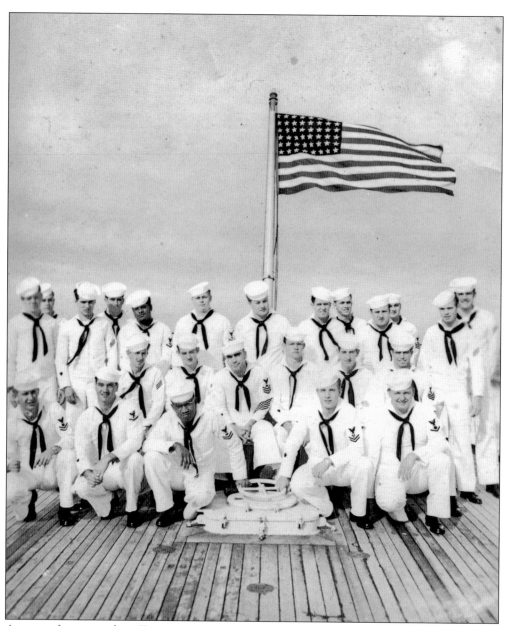

A group of crewmen from *Taney's* engineering department gather on the fantail. The small, dark patch on the right uniform sleeve near the cuff is the Coast Guard shield. The shield distinguishes the uniform from that of the US Navy. Prior to 1974, Coast Guard uniforms were identical to Navy uniforms except for the shield. Note the teak wood deck laid over the steel main deck. *Taney's* original teak deck was replaced with Douglas fir in 1962. This photograph was taken while the ship was moored or anchored, as indicated by the flag flying from the flag staff. The national flag flies from the mast when the ship is underway. Note that the flag has 48 stars.

Five

THE 1960s

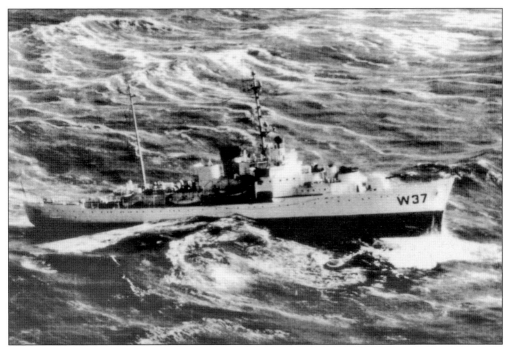

Taney is proceeding at high speed in heavy seas on February 9, 1960, in response to a distress call from the wine tanker SS *Angelo Petri*. The tanker was hauling about 1.7 million gallons of wine when it was disabled by a huge wave near the entrance to San Francisco Bay. The wave sent water down the tanker's funnel, shorting out its main switchboard. The ship drifted out of control nearly six miles before its anchors caught hold. The crew was rescued by the Coast Guard, and the ship was towed to safety.

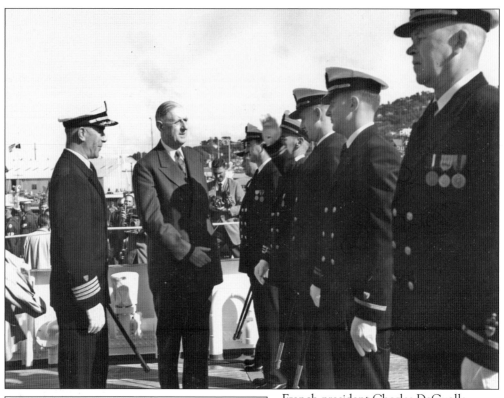

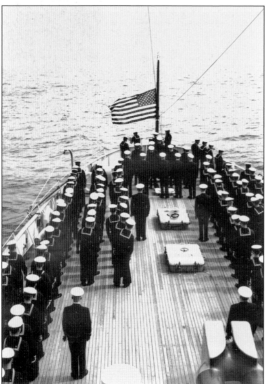

French president Charles DeGualle inspects *Taney's* officers during a state visit to the United States. At left is *Taney's* commanding officer, Captain Frank V. Helmer. After visiting Washington, DC, and addressing Congress on April 22, 1960, DeGaulle's official party arrived in San Francisco on April 27 and was given a VIP cruise around San Francisco Bay aboard *Taney*.

US Navy and Coast Guard ships are sometimes called upon to perform a burial at sea ceremony. Usually the burial is the cremated ashes of a retired or honorably discharged veteran. The ceremony is part religious and part military. The religious part is performed by a chaplain or the commanding officer. The military part is done by an honor guard, which fires a volley salute and plays taps. Here, *Taney's* crew forms on the quarterdeck for the ceremony. The crewman standing under the flag is emptying the ashes into the sea.

The chief petty officer community is a close fraternal organization. Advancement to chief is based on an individual's time in service, exemplary evaluations, and specialized technical exams. Advancement in both the Coast Guard and the Navy also involves a change of uniform that distinguishes the chief from the lower enlisted ranks. Part of the acceptance into the chief community involves an indoctrination period and some playful hazing, as seen here.

A crewman takes a quick nap while resting on Oscar, a dummy stuffed with flotation material that is used to practice recovering a person who has fallen overboard. Man overboard drills are conducted regularly to sharpen the crew's recovery skills. During an unannounced drill, Oscar is thrown over the side and "Man Overboard" is yelled. The bridge and combat information center are notified, and work together to track Oscar and maneuver the ship to effect the recovery.

Two crewmen place a rat guard on the mooring line between the ship and the dock. The guard is to prevent rats and other unwanted visitors from using the mooring lines to gain access to the ship. Hopefully the rat guard is not in its final position, because rats can still jump onto the shipboard side of the mooring line from the dock where the crewman on the right is standing.

This is a life ring with a water light. It is thrown near a person who has fallen overboard. Hopefully the person in the water can swim to the ring and use it for support until rescued. The light is activated once it is in the water to help locate the person, especially at night. Smoke flares are also thrown in the water as another means of locating the person. People standing on deck continue pointing to the person in the water to assist bridge personnel in maneuvering the ship close to the person.

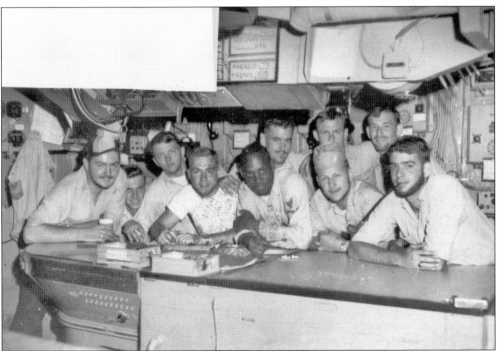

The combat information center, also known as CIC or just "combat," is the tactical center of the ship. Those who work there collect information by radar, sonar, and radio, then display the information, evaluate it, and disseminate it to the command center on the bridge. Shown here is the 1966 CIC team. From left to right are Radarman Third Class Bagdon, Radarman Seaman Maxin, Sonarman Third Class Rodkey, Sonarman Second Class Ruenyer, Sonarman Third Class Hutchinson, Radarman Seaman Murdoch, Ensign Kurtz, Sonarman Second Class McCabe, Sonarman Seaman Branot, and Sonarman Seaman Martin.

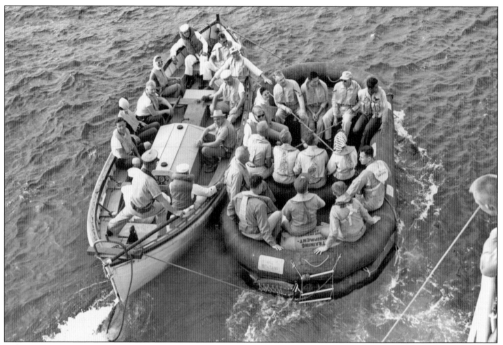

Above, one of *Taney's* 25-foot motorboats maneuvers an inflatable life raft loaded with civilians alongside the ship. This was part of a joint training exercise for the Coast Guard and airline personnel who routinely flew between the US mainland and Hawaii. The training benefited the *Taney* crew, who might be called upon to rescue downed airline passengers and crew. The airline crew benefited from learning Coast Guard rescue methods in case they were forced to ditch. Below, *Taney* crewmen assist airline personnel aboard the ship from the inflatable rafts. Such exercises were usually conducted in calm conditions, but an actual rescue could be in dangerous sea conditions, making it challenging for both the Coast Guard and the plane's crew and passengers.

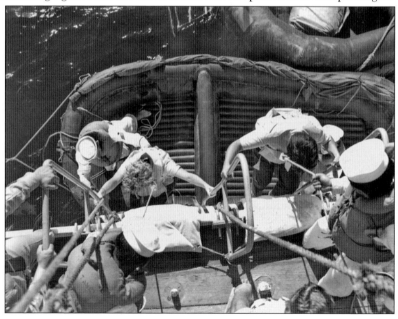

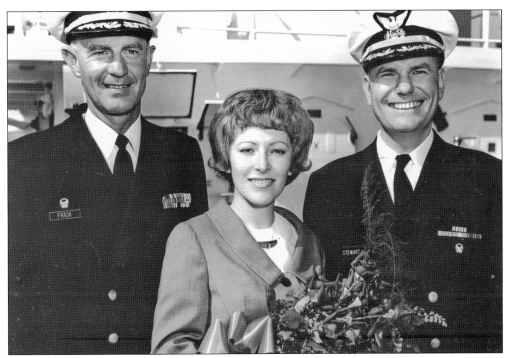

Susan Schucker was a United Airlines flight attendant on one of the many commercial airline flights that passed over Ocean Weather Station November, halfway between California and Hawaii, patrolled by the US Coast Guard. *Taney's* crew voted her Miss Ocean Station November in a contest with other flight attendants who flew over the station. Schucker came aboard to tour the ship and dine with the crew. Above, she stands with Cap. Sherman K. Frick, commanding officer, and Comdr. James P. Stewart, executive officer, while the ship is moored at Government Island, Alameda, California. Below, Schucker sits amidst members of the crew, who presented her with a bouquet of roses, a photograph of the ship, and a certificate. Schucker was selected from nearly 400 candidates.

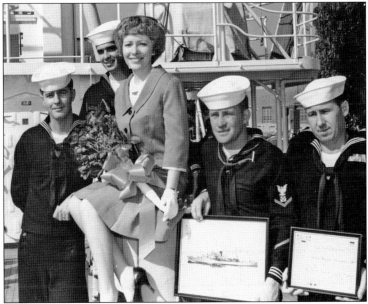

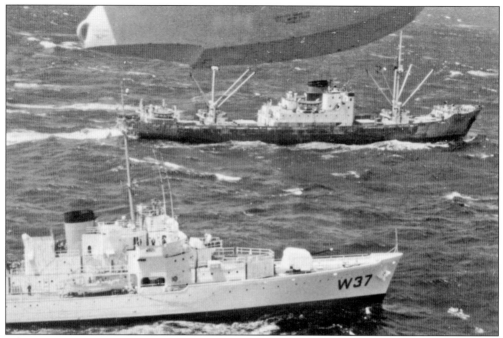

On May 1, 1966, *Taney* was redesignated a high endurance cutter, or WHEC. During the month of May, *Taney* was assigned the task of shadowing surveillance on a Russian commercial vessel, the 3,550-ton refrigerated cargo ship *Chernjakhovsk*, which was sailing in international waters off the northern California coast. The ship warranted surveillance because Russian commercial ships were known to carry electronic surveillance equipment to monitor US radio transmissions.

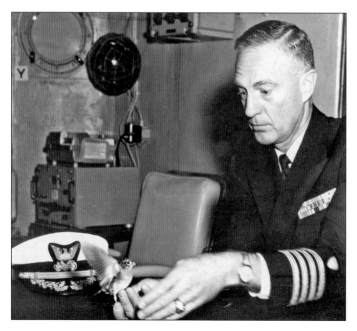

Capt. Sherman K. Frick, commanding officer from 1965 to 1968, holds a small bird in his cabin in 1966. The bird flew aboard *Taney* from a passing ship while the cutter was on Ocean Weather Station Victor in the Pacific. The small bird was dubbed "Little Stupid" by the crew, since it was a land bird and *Taney* was about 1,200 miles from land at the time. The ball hanging in the background is a Japanese glass fishing net float. Larger versions of the glass balls were often mistaken for floating mines during World War II and were destroyed by gunfire.

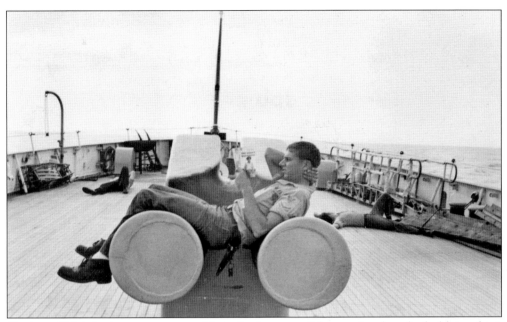

Shipboard life is both monotonous and fatiguing because of the rotational method of doing ship's work and standing watch. Therefore, sailors in the Coast Guard and Navy take every opportunity to relax and catch a quick nap. Here, two crewmen lay on the deck for a short snooze in the sun while another lounges on the ship's towing bitt and reads.

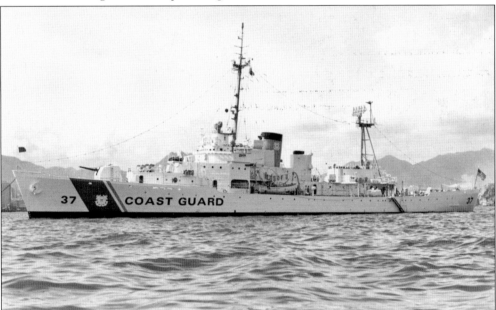

Taney is pictured at anchor in 1969 in Hong Kong during Operation Market Time after the addition of the "racing stripe." The stripe was adopted by the Coast Guard in 1967 to distinguish its vessels and aircraft from those of the Navy. The large rectangular antenna on the tripod mast near the rear of the ship is for the AN/SPS-29 radar. This was a long-range air search radar that was necessary to track commercial airliners and other aircraft over the ocean while the ship patrolled the ocean weather stations.

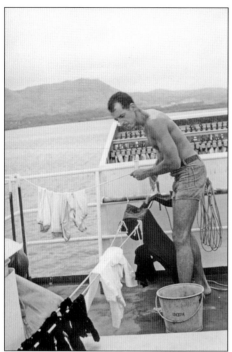

Although there is a full-service laundry aboard *Taney*, this crewman is doing his own in a bucket on the signal bridge. Laundry aboard ship is usually done by everyone in a division putting their laundry in one large bag. When it comes back from the laundry, it is sorted by the crewman's name stenciled on the uniform. Unfortunately, not everything that goes in the laundry always come back. Therefore, doing one's own laundry in a bucket has advantages. The white square box behind the crewman is the "flag bag," where the ship's signal flags are stowed until they are needed. (Garrett Conklin.)

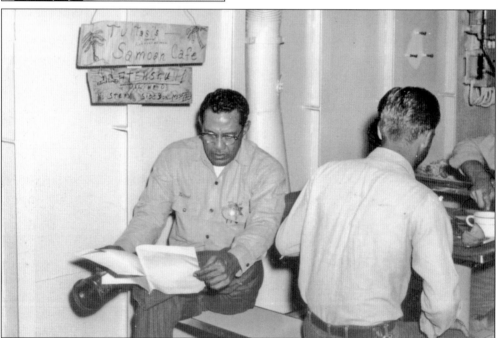

Master-at-Arms Mike Tuitasi, a native of American Samoa, sits reading on the mess deck around 1966. *Taney's* master-at-arms is the ship's policeman, tasked with enforcing rules and regulations. The sign on the bulkhead reads: "Tuitasi's Samoan Café. Attenshun! All hand, no steam shoos on mess deck." The engineers who worked in the fire room and engine room wore shoes that were often covered with soot and oil because of their work below decks. Their shoes made dirty prints on the deck of the mess, and Tuitasi banned them.

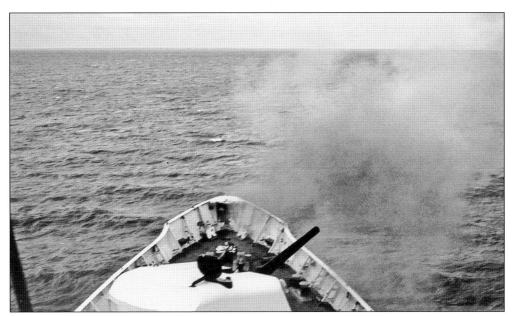

The 5-inch/.38-caliber gun on *Taney's* bow fires at enemy troops in South Vietnam. This activity was known as a naval gunfire support mission (NGFS). Usually, a NGFS mission was initiated by allied troops ashore calling the location of enemy troop concentrations to the ship by radio. The ship would move close to shore and aim at the appropriate coordinates. Allied troops observed where the shells landed and radioed any corrections necessary. (Garrett Conklin.)

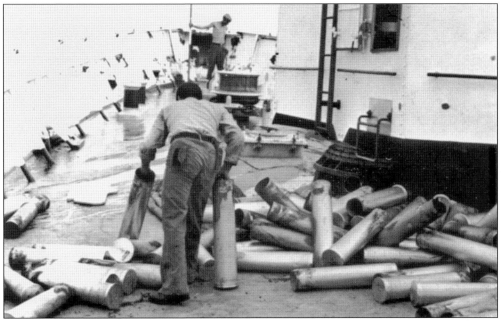

Spent 5-inch/.38-caliber casings litter the main deck around the gun mount after a NGFS mission in support of American and allied troops. During *Taney's* eight-month deployment to Vietnam, she conducted 149 NGFS missions in which she fired 95 tons of high explosives—over 3,400 rounds of ammunition. Taney operated along with US Coast Guard high endurance cutters *Spencer*, *Mendota*, *Sebago*, and *Klamath*.

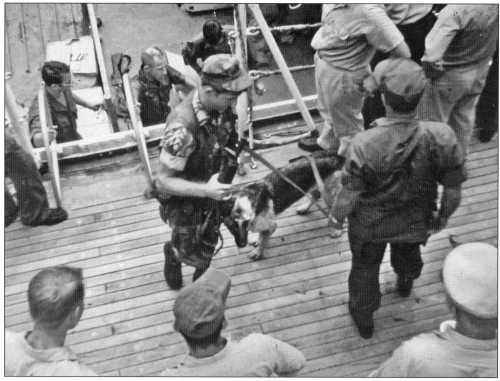

In August 1969, Taney transported a company of the US Army 173rd Airborne Brigade to the Mekong Delta. The ship remained in the area and provided naval gunfire support for the 173rd, a South Korean Army division, and a South Vietnamese Army division. *Taney's* targets were enemy bunkers, tunnels, and camps in Bien Dinh and Bien Thuan provinces. Above, troops board the ship from a landing craft with a "war dog." Dogs were used for security around US camps after they moved inland. Below, troops of the 173rd Airborne Brigade gather on the stern of the ship in preparation for transport to the combat area. (Bill Morgan.)

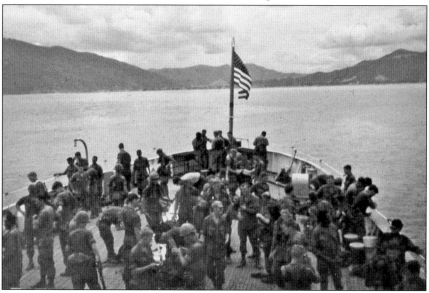

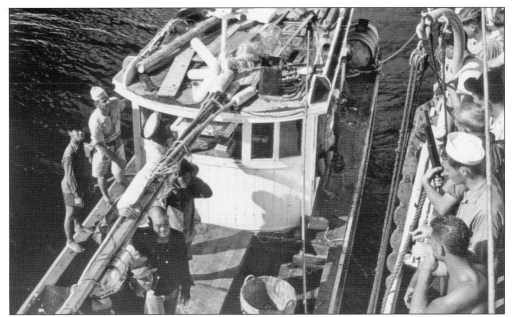

An important part of the Coast Guard's mission in Vietnam was the interdiction of enemy troops, weapons, and supplies being transported by small boats. The boats moving the contraband would intermingle among hundreds of small South Vietnamese fishing boats, making their identification difficult. During her 10-month tour, *Taney* detected about 1,600 vessels in the area, inspected about 1,000, and boarded 30. This is one of the vessels stopped and boarded by *Taney* crewmen for inspection. Chief Gunner's Mate Lloyd Berry, dressed in khakis, conducts the inspection. (Glenn Hangard.)

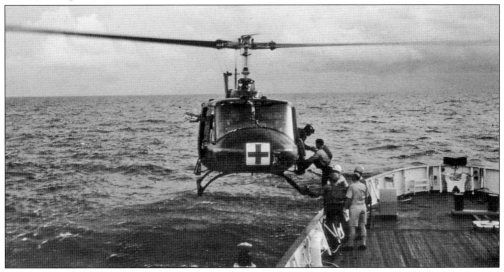

While patrolling the waters off Vietnam, *Taney* was called upon to assist in the evacuation of three sailors in need of medical attention. After the three men had been transferred to *Taney*, a US Army medevac helicopter arrived to pick them up. The helicopter hovered over *Taney*'s quarterdeck while the first two men were hoisted aboard. When the hoist broke, the pilot skillfully maneuvered beside *Taney* and held it there while the third man climbed from the ship onto the helicopter. (Bill Morgan.)

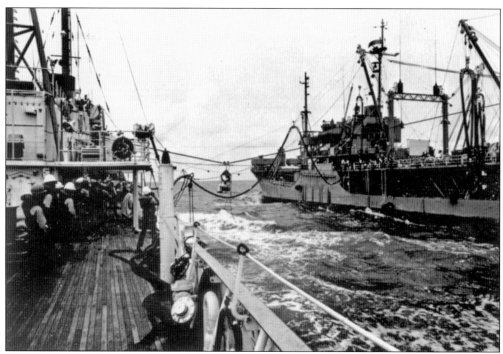

Replenishment at sea is the method used to extend a ship's underway endurance. Most replenishment operations are conducted between ships moving side by side at a standard distance apart and at a constant speed. Fuel, ammunition, and dry bulk goods can be transferred to the receiving ship by this method. During such operations, experienced helmsmen are required to ensure both ships maintain a constant course and speed. Underway replenishment has become so efficient that the only reason a ship needs to enter port is to provide rest and relaxation for a fatigued crew. Below, vertical replenishment, "VertRep" in nautical lingo, is a faster way to transfer large quantities of cargo from ship to ship, done by helicopter. Below, a Navy UH-46 Sea Knight helicopter from the combat stores ship USS *Niagara Falls* (AFS-3) lands a net full of cargo on *Taney's* after deck.

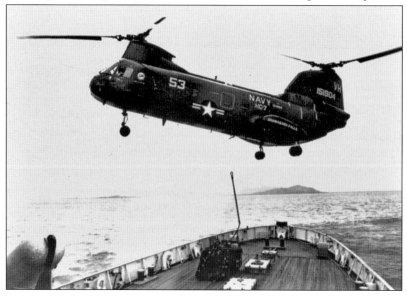

Six

THE 1970s

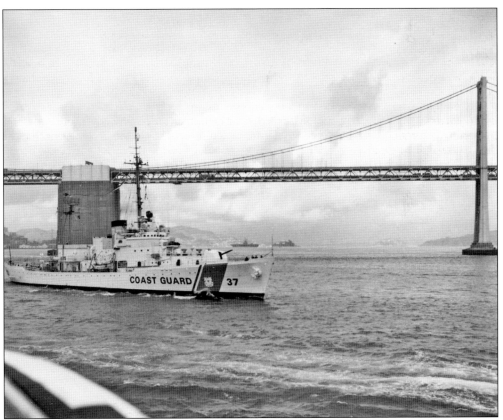

Taney passes under the San Francisco–Oakland Bay Bridge as she returns from her deployment to Vietnam. She is on her way to her mooring pier at Coast Guard Island, where families of the crew are waiting. The ship had arrived outside San Francisco Harbor in the early hours of March 3, 1970, to bide her time until the welcoming committee had assembled at the pier. *Taney* streamed a 160-foot banner from her mast, one foot for each member of her 160-man crew.

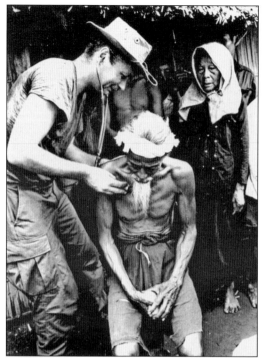

During *Taney's* Vietnam deployment, members of her medical staff went ashore to visit several villages in South Vietnam to offer medical aid to civilians. It was part of MEDCAP, or Medical Civilian Assistance Program, an effort to promote the loyalty of the South Vietnamese people to their government and its allies. At left, Dr. Stephen Bartok, US Public Health Service, examines an elderly South Vietnamese man in one of the villages. Below, Coast Guard hospital corpsman Ken "Doc" Fincher examines a small child. *Taney's* staff treated nearly 6,000 South Vietnamese as part of MEDCAP. Because *Taney* carried a doctor aboard, she was also subject to being called by other vessels to provide medical assistance to ill or injured crewmen.

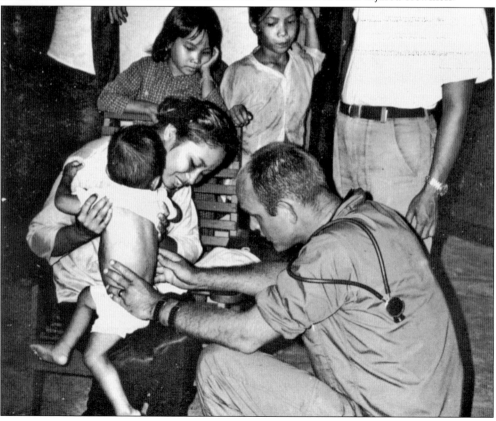

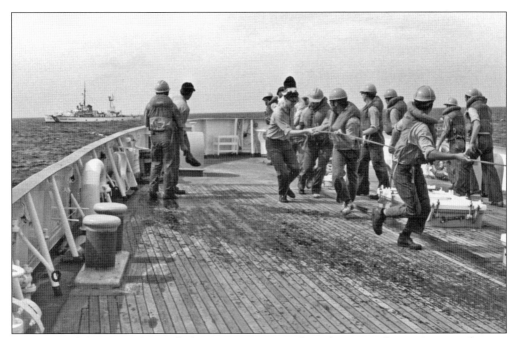

Coast Guard ships are often called upon to assist vessels in distress and, at times, tow them to safety. They also might need to tow a vessel apprehended as part of their law enforcement duties. Crewmen aboard *Taney* pull a tow line onto their ship as part of a towing exercise with Coast Guard *Wachusett*. The two cutters were together to exchange duties on Ocean Weather Station Victor relief.

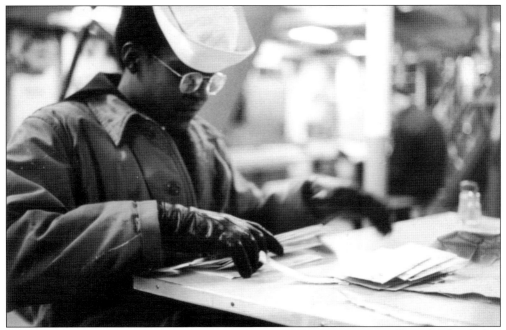

A *Taney* sailor receives mail while on patrol in 1972. Isolation at sea, especially in the days before digital communications, was relieved by the welcome arrival of mail from home—usually received from another passing Coast Guard cutter via highline transfer.

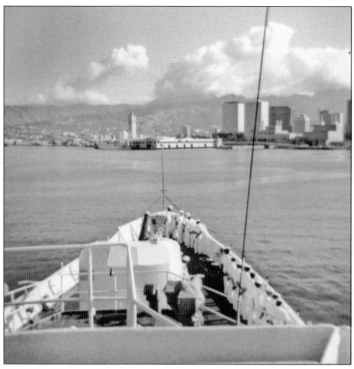

The Honolulu skyline is shown ahead of *Taney* as she enters port. Pier 6, where she was moored on December 7, 1941, is off the bow. The Aloha Tower is just to the left of the bow at Pier 9. The Aloha Tower, a well-known Honolulu landmark, is actually a lighthouse opened in 1926. One of the reasons for *Taney* being moored close to the tower in December 1941 was to prevent it being occupied if the island was invaded. The crewmen standing on deck are "manning the rail," which is a method of saluting or rendering honors as the ship leaves or enters port.

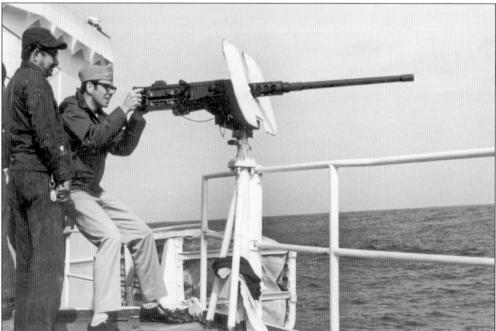

Taney's medical officer, Lt. Comdr. Larry Dunlap, US Public Health Service, takes a turn at a .50-caliber gun during machine gun practice while the ship is on Ocean Station Victor. An empty oil drum was thrown over the side as a target. When the drum had floated an appreciable distance from the ship, target practice began. The trick to hitting the drum was to compensate for the roll of the ship while riding the swells. (George Brungot.)

Two crewmen deploy a Nansen bottle from *Taney* to take an ocean water sample from a specific depth. This was known as a Nansen cast. The bottle descended to the depth on a cable. A brass weight was then sent down the same cable, and when it reached the bottle, the impact tilted the bottle, trapping the sample. The bottle was then hoisted back up the cable. (George Brungot.)

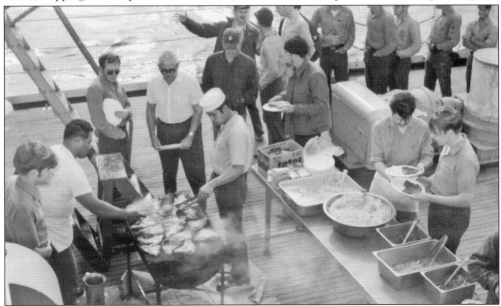

Ship's crewmen enjoy a "steel beach" barbecue on the quarterdeck around 1971. The steel beach barbecue gets its name from a cookout traditionally enjoyed at the beach but here on the deck of a ship. The usual barbecue foods were prepared for the crew by the ship's cooks, including steak, chicken, burgers, hot dogs, potato salad, beans, and snack foods. The only thing missing was beer, because alcohol was prohibited aboard US ships. The civilian at the foot of the ladder is a National Weather Service technician. (George Brungot.)

National Weather Service technicians inflate a weather balloon in the balloon inflation shelter aboard *Taney*. The helium-filled balloon was sent aloft with a radar reflector and expendable instruments to collect data on atmospheric pressure, temperature, humidity, and wind speed. The collected data was transmitted back to the ship, where it was recorded and then sent to a shore station. (George Brungot.)

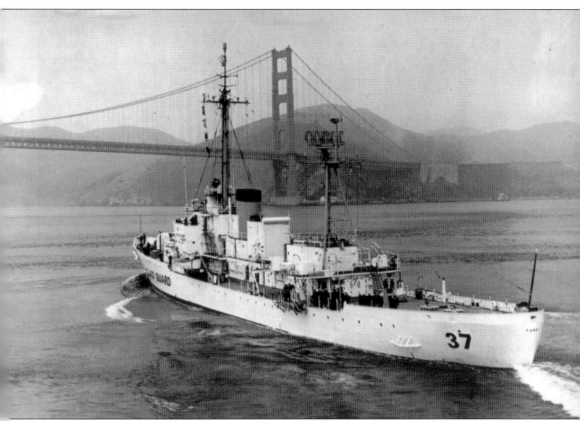

In 1972, after 26 years being home ported in Alameda, *Taney* was transferred from the 12th Coast Guard District to the 5th Coast Guard District on the East Coast. Her new home port would be Little Creek, Virginia. Here, "The Queen of the Pacific," as the ship had come to be known, is about to steam beneath the Golden Gate Bridge for the final time, on February 8, 1972.

Lt. Gordon Reddick of *Taney* poses with two Japanese fishermen aboard their fishing boat. Fishery inspections were conducted in a friendly and non-adversarial manner. US Coast Guard crews came aboard the fishing vessel as a team. Each Guardsman had a specific duty to perform in a timely manner so as not to put an undue burden upon the ship and crew being inspected. (Gordon Reddick.)

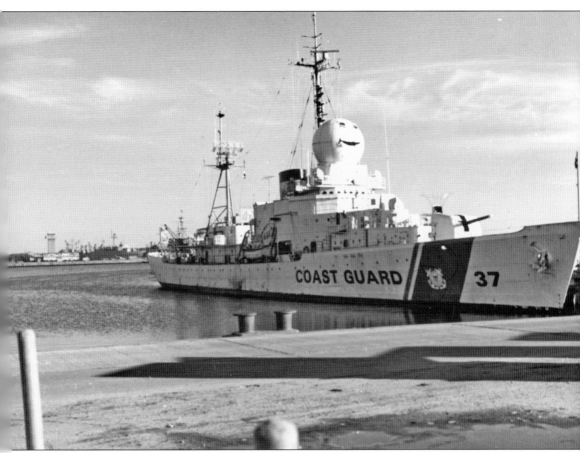

In 1971, the Coast Guard transferred *Taney* from Alameda, California, to Norfolk, Virginia. *Taney* is seen docked at the US Coast Guard station in Portsmouth, Virginia, on Christmas 1973. The "golf ball" painted with a smiley face atop *Taney's* bridge was a protective enclosure for the weather search radar. The radar was installed during a major overhaul at the Curtis Bay Coast Guard Yard near Baltimore, Maryland. The radar and its enclosure were a hand-me-down from the decommissioned cutter *Gresham*. The new radar was necessary for duty on Ocean Station Hotel. (George Brungot.)

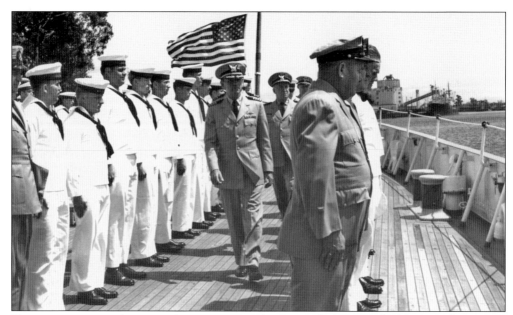

Taney crewmen stand personnel inspection on the quarterdeck. Note the likeness of US Coast Guard uniforms to those of the US Navy. The likeness began in the 1940s, when the Coast Guard adopted Navy standards. A notable difference from the Navy was the Coast Guard's use of the white flat hat in the 1960s and 1970s. A major change to the Coast Guard uniforms came in 1974, when the service shifted to "Bender Blues" to distinguish itself from the Navy. Bender Blues got their name from Adm. Chester R. Bender, commandant of the Coast Guard from 1970 to 1974, who instituted the change.

Capt. Robert Ogin administers the oath of re-enlistment to Boiler Technician Second Class Tito in the captain's cabin in October 1971. Tito, from American Samoa, had already served eight years, as indicated by the two hash marks on his lower left sleeve. Boiler technicians operated the equipment that produced steam for the ship's propulsion.

Coast Guard and Navy ships receive refresher training from the Fleet Training Group at US Naval Station Guantanamo, Cuba, to determine if they are combat ready. Experienced senior enlisted personnel from the Navy and the Coast Guard evaluate and grade a series of exercises each ship must participate in during its time at Guantanamo. Here, the Navy tugboat *Wanamassa* edges *Taney* to the pier for docking.

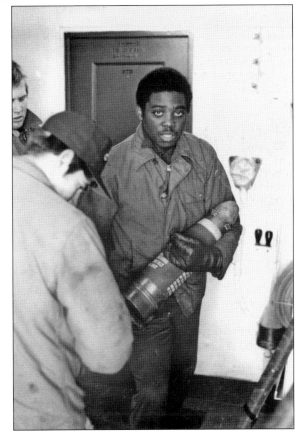

Part of the training and evaluation at Guantanamo by the Fleet Training Group is a live-fire gun shoot. Prior to departing Norfolk for refresher training, *Taney* took on a full load of ammunition. A *Taney* crewman carries a 5-inch/.38-caliber projectile for stowage in the ship's magazine. Special safety precautions were always taken when loading and off-loading ammunition and when refueling. The "smoking lamp" was out during such evolutions regardless of whether the ship was at sea or in port.

A ship's homecoming after a deployment is always a big event for both the crew and their families. Above, *Taney* crewmen join their loved ones on the pier in the Coast Guard base at Alameda, California, after a 30-day patrol. Below, upon return to port, Chief Radioman Donald Briscoe walks hand-in-hand with his young son as he gives him a personal tour of "Daddy's Ship."

Crewmen sit on the quarterdeck as they receive first aid training from a Fleet Training Group instructor. Although *Taney* carried medical staff aboard, each crewman had to be knowledgeable of first aid and life-saving techniques in case of emergency. The light patches on the leg and chest of the crewman in front of the instructor are simulated wounds to make the training more realistic.

Taney approaches the sinking fishing boat *Lady Eva* 200 miles off the coast of Maryland on November 8, 1976. With winds blowing at 60 knots and in 30-foot seas, *Taney* left Ocean Station Hotel at full speed after picking up a distress call from *Lady Eva* 15 miles away. With the ship taking 40-degree rolls and daylight almost gone, Capt. Gene Moran maneuvered *Taney* close enough to the sinking boat that Boatswain's Mate First Class Ken Menke was able to throw a heaving line to *Lady Eva*. After an inflatable boat was passed over, the three fishermen climbed in. For this rescue, *Taney* was awarded a Coast Guard Meritorious Unit Commendation. (Gordon Reddick.)

As a result of her performance at Guantanamo, a crewman paints the "Battle E" on *Taney's* stack. The Battle E is an award to recognize ships for operational excellence in addition to superior performance during training exercises and inspections. In this case, the Battle E was awarded for superior performance in damage control, indicated by the letters DC at the bottom. The two hash marks under the E indicate the award was won three times.

Seven
THE 1980s

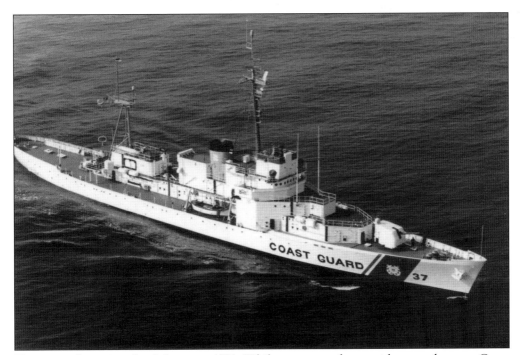

Taney is underway in the Atlantic in 1981. While ocean weather patrol was no longer a Coast Guard duty, *Taney* continued to carry out the service's missions during her last years in commission. These included search and rescue, drug interdiction, fisheries patrols, and training future officers each year during summer cruises with Coast Guard Academy cadets.

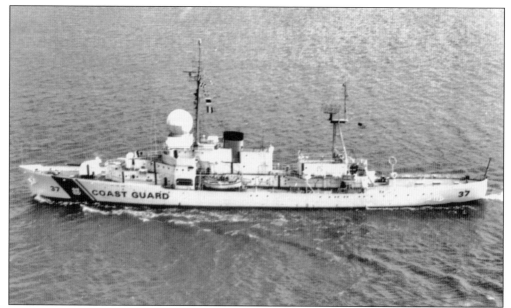

Taney patrols on Ocean Station Hotel. The station, 200 miles off the Delaware coast, was an important weather station because it was in the Gulf Stream, where hurricanes can pop up suddenly. Ocean Station Hotel was the last ocean weather station manned by a vessel. All other ocean weather stations, in both the Atlantic and the Pacific, had been closed or replaced by automated weather data buoys. A weather data buoy collects weather information and transmits it ashore electronically. On September 30, 1977, Ocean Station Hotel was closed when *Taney* departed the station.

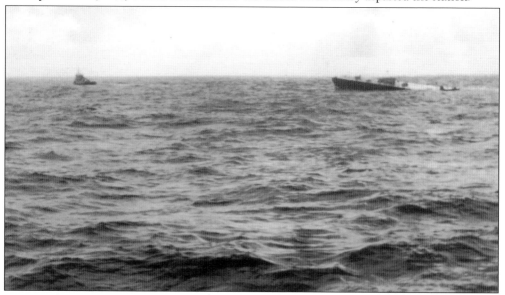

In 1985, the merchant vessel *Sea Maid I*, towing a 175-foot barge, attracted the attention of *Taney* by unexplainably loitering in a 50-square-mile area 300 miles east of Cape Hatteras. *Taney* challenged *Sea Maid I* but received deceptive responses. *Taney* trailed the vessel for a day and a half until *Sea Maid I*'s story broke down. *Taney*'s crew boarded the vessel and discovered 160 tons of marijuana stowed in the barge. At the time, it was the largest drug bust in Coast Guard and US history. (Edward C. Hartman.)

Drug interdiction has always been a major responsibility of *Taney*. She began monitoring cargo ships entering Honolulu for drug smuggling in the late 1930s. Fifty years later, she patrolled the East Coast of the United States looking for drug smugglers. Here, Gunner's Mate Third Class Clint Reierson (right) and another crewman hold a bundle of marijuana aboard a small ship that *Taney* has stopped to inspect because it was suspected of smuggling. (Clint Reierson.)

Taney crewmen guard drug smugglers who have been taken aboard the ship. The detainees were transported ashore to be formally charged. While aboard *Taney*, the detainees ate and slept on the main deck at the stern of the ship. They were escorted to a bathroom when necessary and immediately returned. (Clint Reierson.)

A disabled fishing boat is in tow around 1982. Note that the once resplendent wood deck has been overlaid with a rubber covering as an economy measure to see the ship through its last years in commission. Rendering assistance to vessels in distress remained a regular activity for *Taney* and her crew in the 1980s. Typical of these operations was a November 1982 rescue of a 50-foot ketch called the *Klarwasser* off Cape Hatteras. As reported by *The Virginia Pilot*, the vessel had been "wallowing with its sails blown out in the storm-swept Gulf Stream" when a ham radio operator in Florida picked up a distress call and relayed it to the Coast Guard. The sailing vessel's captain praised the seamanship of *Taney's* crewmembers, who launched a 26-foot motor surfboat in the heaving seas to get alongside the *Klarwasser* and take off passengers before towing the ketch.

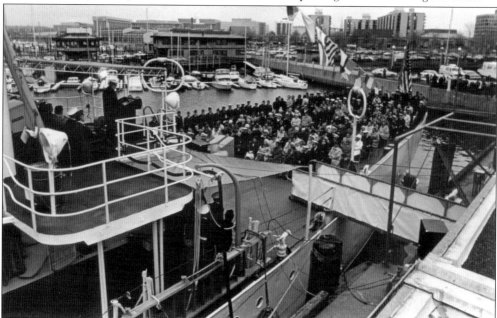

Military and civilian dignitaries, along with World War II *Taney* veterans, gather aboard the ship in Washington, DC, to commemorate the 40th anniversary of Pearl Harbor, December 7, 1981.

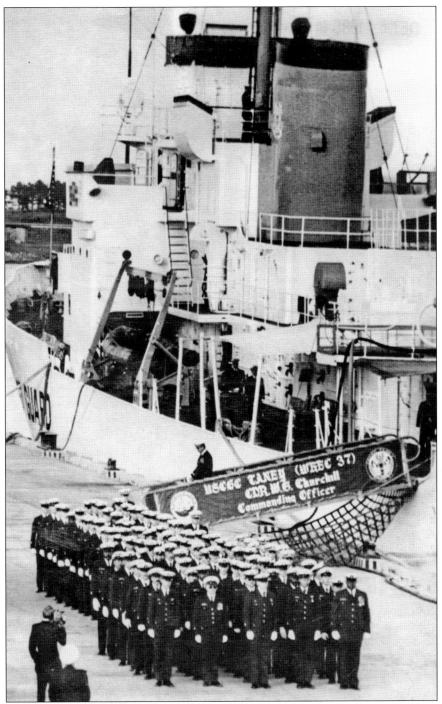

Taney's crew stands at attention on the pier beside the ship on December 7, 1986, in Portsmouth, Virginia, for the decommissioning ceremony. The ship's last captain, Comdr. Winston G. Churchill, walks down the brow to officially leave the ship for the last time. In attendance at the decommissioning ceremony were Majorie B. Coffin, widow of the ship's first commanding officer, and Corinne Taney Marks, who christened the ship 50 years before.

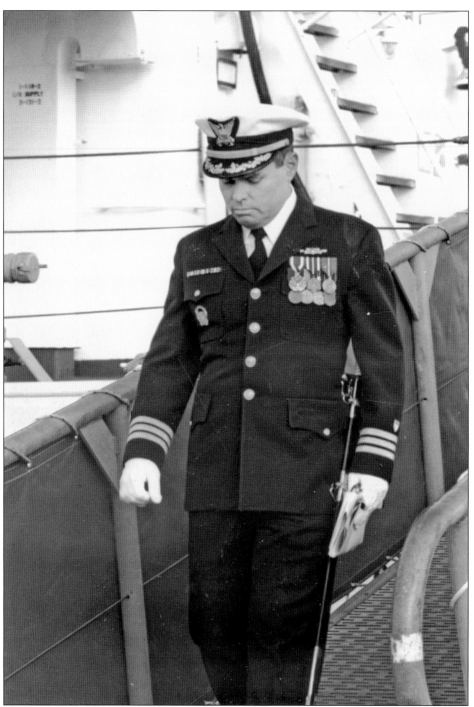

Commander Churchill, no relation to the former British prime minister, was the ship's 29th commanding officer. He assumed command in May 1986. As a goodwill gesture, Churchill ensured that Baltimore, Maryland, was her last port visit before returning to her homeport of Portsmouth, Virginia, for decommissioning. As *Taney* approached her pier at Coast Guard Support Center Portsmouth, Churchill assumed the conn and brought the ship in for the last time.

Eight

Retired but Still Serving

Taney crewmen gather in front of the 5-inch/.38-caliber gun on the bow. They were in Baltimore for a ship's reunion in 2000. Over the ship's 50-year active career, thousands of Coast Guardsmen, US Public Health Service personnel, and National Weather Service personnel served aboard *Taney*. Many ships' crewmen have annual reunions, but most of their ships have long been decommissioned and scrapped. *Taney's* crewmen are quite fortunate to have their reunion upon the very ship where they served. (F. Paul Galeone.)

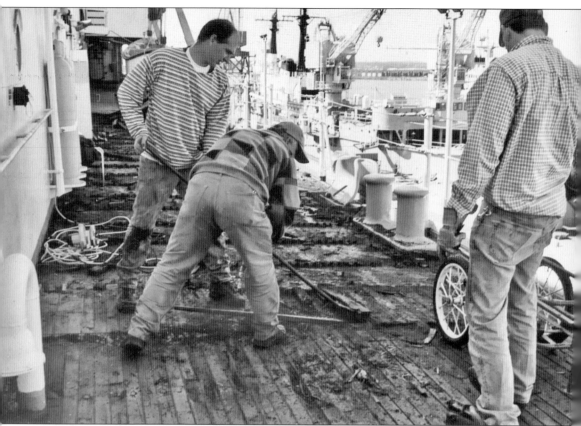

Workers remove *Taney's* wooden quarterdeck in Curtis Bay, Maryland. The wood was in need of repair, and the cost to maintain it was too much for a ship that was no longer under US government funding. The ship is now operated and maintained by Historic Ships of Baltimore by tour ticket sales and other donations. The metal deck under the wood is easily maintained by painting.

Coastguardsmen from Yorktown, Virginia, work on one of *Taney's* doors. Such activity provided valuable shipboard training for shore-based Coast Guardsmen, and *Taney*, now a museum ship, benefitted by having the work done by experienced personnel. The deteriorated condition of *Taney's* main deck can be seen in this picture. A deck in such condition was not suitable for a museum ship that was toured by the public.

Alan Walden, a local Baltimore radio personality, speaks to the many attendees at the annual Pearl Harbor remembrance ceremony on *Taney's* quarterdeck. Walden has been the master of ceremonies at the event for several years. The ceremony is attended by members of all the armed services, family members, civilians, and Pearl Harbor survivors. People attending either sit on the ship's deck near the stern or gather on the pier beside the ship.

Members of the St. Andrew's Society participate annually in the Pearl Harbor Remembrance Day ceremony. Here, members of the society stand in ranks on the starboard side of *Taney's* quarterdeck in preparation for escorting the colors. CPO Tom Harroll, US Naval Reserve, a society member, is the American flag bearer. The society also conducts a bell ceremony in which it strikes a bell for each ship lost at Pearl Harbor. (Author's photograph.)

Thomas Talbott stands aboard *Taney* during the 75th anniversary of the Pearl Harbor attack on December 7, 2016. Talbott was a US Marine who had been in the Pacific for two years and was preparing to return home when Pearl Harbor was attacked. He was standing guard at a dry dock when the attack began. Talbott was a regular attendee of the annual Pearl Harbor remembrance ceremony aboard *Taney*. He passed away at age 96 in May 2017. (Author's photograph.)

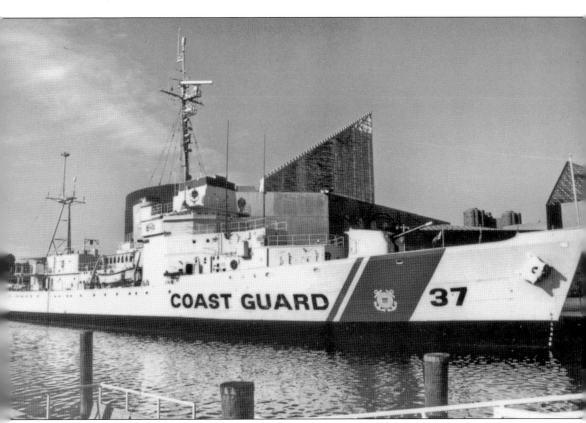

Taney is seen moored at Pier 4 in the Inner Harbor in Baltimore. She now rests at Pier 6 as part of the Historic Ships of Baltimore collection. *Taney* served the United States for over 50 years as a patrol ship, a combat ship, a rescue ship, a weather ship, and a law enforcement ship. Considering she was built for only $2.4 million, the American people got a heck of a deal. She still serves the American people as a museum ship open for tours.

DISCOVER THOUSANDS OF LOCAL HISTORY BOOKS
FEATURING MILLIONS OF VINTAGE IMAGES

Arcadia Publishing, the leading local history publisher in the United States, is committed to making history accessible and meaningful through publishing books that celebrate and preserve the heritage of America's people and places.

Find more books like this at
www.arcadiapublishing.com

Search for your hometown history, your old stomping grounds, and even your favorite sports team.

Consistent with our mission to preserve history on a local level, this book was printed in South Carolina on American-made paper and manufactured entirely in the United States. Products carrying the accredited Forest Stewardship Council (FSC) label are printed on 100 percent FSC-certified paper.

MADE IN THE USA